DUNDEE
AT WORK

DUNDEE
AT WORK

GREGOR STEWART

AMBERLEY

First published 2017

Amberley Publishing
The Hill, Stroud
Gloucestershire, GL5 4EP

www.amberley-books.com

Copyright © Gregor Stewart, 2017

The right of Gregor Stewart to be identified as the
Author of this work has been asserted in accordance
with the Copyrights, Designs and Patents Act 1988.

ISBN 978 1 4456 7070 6 (print)
ISBN 978 1 4456 7071 3 (ebook)

British Library Cataloguing in Publication Data.
A catalogue record for this book is available
from the British Library.

Origination by Amberley Publishing.
Printed in the UK.

CONTENTS

Acknowledgements 6

About the Author 7

Introduction 8

The Eighteenth Century 11

Nineteenth and Twentieth Century 25

Post-Second World War 52

ACKNOWLEDGEMENTS

The writing process for this book has undoubtedly been helped by pieces of information given to me over the years by many people from Dundee and the surrounding area, which I have been able to bring together to add to the story of the industries of this city, and I thank them all. There are, however, some that I need to specifically thank for their help in sourcing photographs for the book. To Barry Sullivan at DC Thomson for the considerable amount of time spent not just helping to find photographs but also in arranging for them to be made available for the book. To Louisa Attaheri from the Dundee Heritage Trust, who not only assisted in searching their own archives but also pointed me in the right direction for where to locate images not held by them. And to Steven Lamb and Dawn Duncan at Michelin, for helping out so quickly in arranging for photographs of the Dundee plant to be released.

ABOUT THE AUTHOR

I was born in Fife, where I still stay, and worked for many years 'across the water' in the City of Dundee. I first became interested in local history as a child, when my grandfather, who was a painter, artist and gold leaf expert, used to tell me tales of the buildings he was working in. The stories from these ancient places initially sparked an interest in the paranormal side – just like any wee boy – but being told a place was haunted was never enough for me; I wanted to know who haunted it, why and what happened. A natural progression was to delve deeper into the history of the towns and places to discover more about the development and the people. As a result, I have written a number of local history books exploring different aspects of various towns and areas.

I do hope you enjoy the book and I welcome any feedback or additional information anyone may have. You can contact me through my website at www. gstewartauthor.com, or find me on Facebook at 'Gregor Stewart, Author and Paranormal Researcher'.

INTRODUCTION

Sitting on the banks of the Tay Estuary on the east coast of Scotland, Dundee is today the fourth largest city in Scotland, with a population of around 148,000 people. The origins of the city can be traced back as far as the time of the Picts. It was however not until around the thirteenth century that it began to grow, thanks to the natural harbour offered by its position on the river. The town grew as the shipping industry grew, primarily trading with the ports of the Baltic Sea, importing timber, and with France and Spain, importing wine and grain while exporting wool and woven products.

Dundee suffered badly after an English fleet attacked it in the sixteenth century, and it suffered further destruction during the seventeenth century when Royalist forces besieged the town, followed by the army of Oliver Cromwell during the Civil War. It took Dundee around 100 years to recover, again thanks to the importance of the rebuilt port. Whaling became a major industry, as did the production of linen, flax and threads that were all exported and in high demand. A Spanish ship seeking shelter in the port from a storm is also said to have provided the raw ingredients for an experimental fruit preserve that grew into a jam empire.

The nineteenth century saw the shipbuilding industry grow, and the linen trade replaced by jute, the production of which would go on to become the main employer in the city. The production of postcards and greeting cards also began to increase. Living conditions improved as a result, with gas lighting being introduced in the 1820s, and a water company being formed in the 1840s, bringing piped water to the premises in the city. A main sewer network was also established in the 1870s to improve sanitation, horse-drawn trams became a regular sight on the streets, improving transportation for the city's workforce, and parks were established to create a better environment for the population when not working. The construction of the Tay Rail Bridge in 1878 also improved transport links for both people and the businesses, to other parts of the UK. By the twentieth century, horse-drawn trams were being replaced with electric models and journalism had begun to grow as an industry. The city, however, was once again to suffer badly during the Great Depression, which saw massive declines in the shipbuilding

and whaling sectors. Shipbuilding returned to the city briefly during the Second World War, but yet again went into decline after 1945, ending completely in 1982.

Dundee again showed remarkable resilience and soon reinvented itself, building on some of the surviving industries and encouraging new commercial enterprises to set up in the city. Timex came to the city and started to manufacture watches that were shipped worldwide, and the American computer and electronics manufacturer

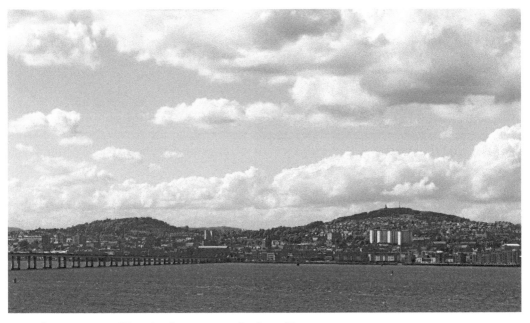

General view of Dundee from across the River Tay.

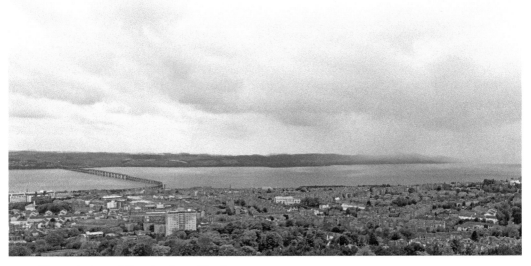

General view of Dundee from The Law.

General view of Dundee from The Law.

National Cash Register established a factory on the Kingsway. The opening of the Tay Road Bridge in 1966 replaced the old passenger Ferry, further improving transport links with the city, and in 1974 Ninewells Hospital opened offering teaching and research facilities, as well as hospital care for patients. The Technology Park encouraged companies such as the Perth-based insurance giant General Accident to open a large office taking advantage of new technology to allow the London area to be served from Dundee. Following on from the other fledgling high-tech industries and the growing animation sector, video game production also established itself in the Technology Park, establishing Dundee as the market leader. The discovery of oil in the North Sea saw the empty docks filling once again as a main repair facility for the oilrigs; its deep-water berths led it to become one of the main ports serving the North Sea Oil and Gas industry. The history of the city also offered new opportunities, with jute mills being converted to housing to accommodate the increasing population, as well as providing museum facilities, giving people a glimpse into one of the industries on which the city was built. In 1986, the RRS *Discovery* returned to Dundee, initially berthed in the Victoria Dock before moving to the purpose-built Discovery Point in 1993, becoming a museum to Dundee shipbuilding and Antarctic exploration. With Dundee starting to firmly become a popular destination for the tourist and travel industry, a £1 billion redevelopment of the Dundee Waterfront commenced in 2003, which included a number of hotel facilities and a flagship V&A Museum of design, providing an international centre for design in Scotland, the first design museum to be built outside of London in the UK.

THE EIGHTEENTH CENTURY

The eighteenth century was to be an important time for Dundee. The Act of the Union with England had opened up a whole load of new opportunities by giving access to the trade routes formerly only open to the English. Merchants across Scotland soon started to monopolise on these, and Dundee found itself in a prime positon to be able to grow.

SHIPPING

Dundee had established itself as an important port for import and export due to the Tay Estuary offering one of the few places along the east coast of Scotland where large ships could seek refuge and safely dock. Ship repair and maintenance were also offered at the port, and it is likely that these facilities developed into shipbuilding. It would appear that the shipbuilding yards were first established around the 1720s. However, it was not until around 1765 that the first sloop boat (a single-masted sailing boat with the mast and sail towards the front) set sail from Mr Smith's shipyard. By then, Dundee had established itself as a vital whaling port, and the demand on shipbuilding grew steadily. Work to construct new docks between 1820 and 1875, and the railway arriving at the docks in 1838 saw significant changes, and some of the existing shipbuilding yards were reclaimed to create the land required.

The railway did not only improve transport links to move items from the port, but it also provided better facilities to bring materials in, which included construction materials for the new shipyards, such as iron and machinery for the engines. The jute industry had exploded in the city, which relied on whale oil and, despite a global decline in whaling, the Dundee Yards were busier than ever building new whaling ships to meet the demand for whale oil. Ships to both bring the raw jute in from India and export the finished products around Europe were also being built. The city was known for producing some of the finest vessels, including the 264-foot-long clipper ship, *The Lochee*, built by Alexander Stephen & Sons, which in 1888

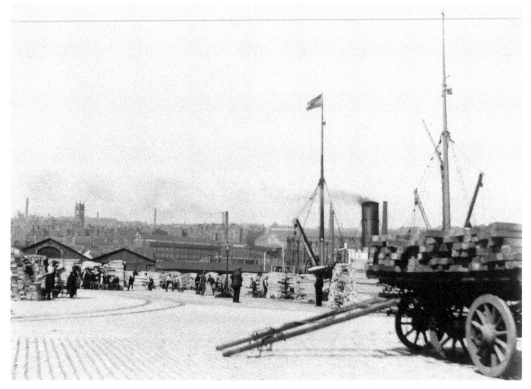

Ship offloading timber at Dundee Harbour. (Courtesy of Dundee Heritage Trust)

set a record time for sailing from Calcutta to Dundee in 113 days. Whale oil processing plants and tanneries for the sealskins were also constructed around the port, creating additional employment on the back of shipping and shipbuilding.

The end of the nineteenth century and start of the twentieth century saw the largest ship built on the Tay, the 450-foot-long, four-masted baroque *Bengali*, constructed at the Gourlay Brothers shipyard. However, by then the jute industry was in decline, which had a significant knock-on effect on both the shipping and whaling industries, with whaling ships that had been lost at sea no longer being replaced. Fortunately, a new opportunity arose, and again Dundee was perfectly placed to take full advantage.

The waters of the Antarctica remained uncharted and the land unmapped at that time, and Sir Clements Markham, the president of the Royal Geographical Society, had begun planning for a British National Antarctic Expedition. By 1900, he had the funds but needed a ship. Dundee had already provided ships that took part in the Arctic explorations, and with the shipbuilders' expertise at constructing ships that could withstand the harsh environment and crushing ice, the Dundee Shipbuilders Co. were commissioned with the task. The Royal Research Ship *Discovery*, as it was to become known, was based on the design of the whaling ships, but was designed solely for carrying out scientific research. This brought some complications with the construction as magnetic surveys were

planned as part of the studies, meaning an exclusion zone for any iron or steel of 30 feet was put in place around the magnetic observatory on the ship, to ensure the findings were not distorted. Although coal engines were fitted to the ship, it was primarily constructed as a sailing ship to preserve the coal supplies. Three masts held the massive sails, with one housing a crow's nest 110 feet above the deck. To allow this to be used in the Antarctic, holes in the side allowed observation of the surrounding area while the unfortunate member of the crew assigned with the task could remain inside, sheltering from the worst of the extreme climate. The ship was launched into the Tay on 21 March 1901 by Lady Markham and was described as a 'bad sailer', primarily due to it being designed to cope with the ice fields that affected its stability in the open water. Captain Robert Falcon Scott had been appointed to lead the expedition and he took personal charge of the preparation, and on 6 August the ship left the dock at the Isle of Wight to start its long journey. Among the forty-eight-man crew there was a zoologist, a biologist, a physicist, a geologist and a surgeon and botanist, each assigned with research work within their own particular specialism.

The expedition was a great success, with hundreds of miles of coastline, mountain ranges and glaciers mapped, along with over 500 new species of animals

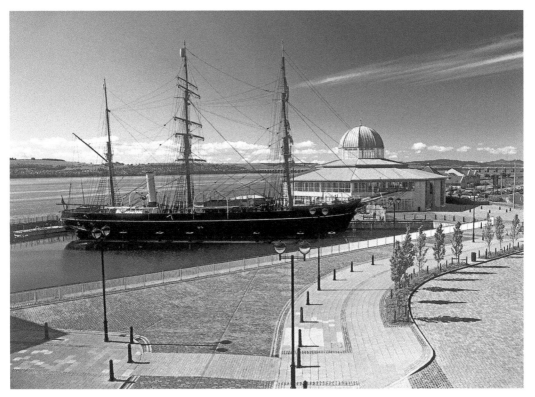

The *Discovery* at its purpose-built dock with the Discovery Point visitor Centre beside. (Photo Courtesy of Dundee Heritage)

and sea life discovered. While exploring and mapping the land, the sleigh dogs started to die due to malnourishment, and the extreme conditions eventually started to take its toll on the explorers. In February 1903, they arrived back at the *Discovery*, which was still locked in ice where it had been anchored for the winter. With no let-up in the ice fields over the summer months, there was still around 20 miles of ice between the ship and the open ocean when, in January 1904, two relief ships arrived and using controlled explosions, were able to free the ship. One of the relief ships was the *Terra Nova*, a whaling ship built in Dundee, and it seems that Scott was so impressed with its performance that he later purchased it for his 1910 research trip back to Antarctica, where he and several crew members would sadly lose their lives while returning from an expedition to the South Pole.

Both the Dundee-built ships continued to be used for many years, a clear sign that despite being exposed to the harshest of conditions, they were built to last. In 1943, the *Terra Nova* was sunk off the coast of Greenland, and in 1986 the *Discovery*, which had been used as a training ship in London for over forty years, returned to Dundee as a 5-star visitor attraction, bringing with it renewed interest in Dundee's shipbuilding past. The ports that once produced so many grand ships have also been repurposed, and now serve as docks repairing oil rigs from the North Sea oil fields.

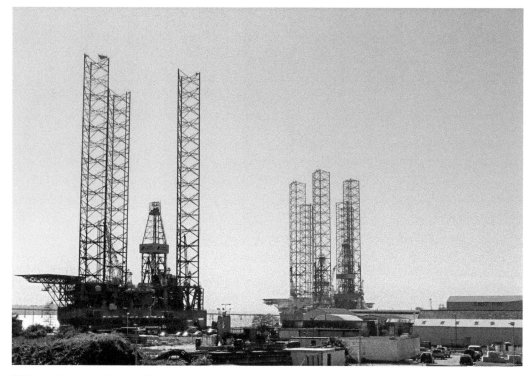

Oil rigs sitting at Dundee Port.

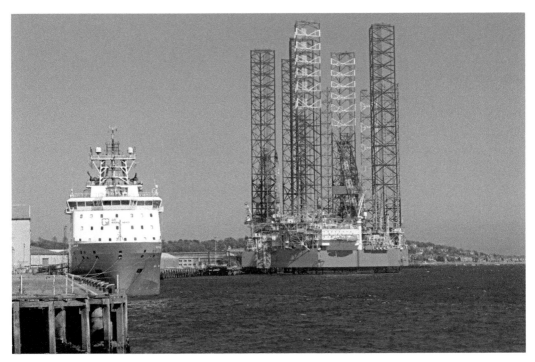

Oil rig and supply ship at Dundee Port.

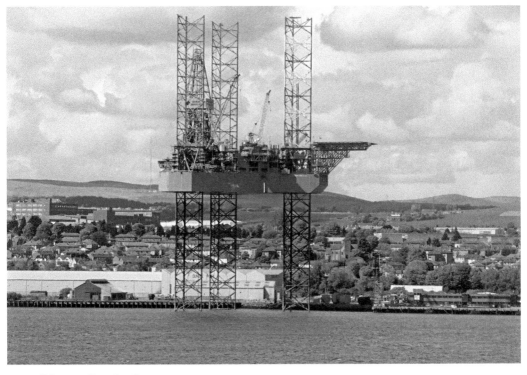

Oil rig at Dundee Port.

WHALING

Although met with overwhelming levels of disapproval today, the whaling industry was once a vital industry for many countries and cities. Whaling in Dundee can be traced back to 1753, when the aptly named ship *Dundee* set sail. Whaling was already big business, and Dundee's position on the Tay Estuary, offering a sheltered harbour with deep water and direct access to the North Sea, made it the ideal location for launching expeditions to the Arctic Ocean. In addition to whales, seals were also hunted for their pelts.

Within just a few years, Dundee was recognised as an important port for whaling and before long construction of ever-advancing ships started from newly established shipbuilding yards. The whale oil was used to power the oil lamps throughout the city and provided heating for those who could afford such luxury. In addition to the demand for the oil that was also used to lubricate machinery, sealskins for warmth and whale bones for the manufacture of items such as chair backs and corsets were shipped all over Europe from the already established export port in Dundee. The captains of whaling ships also provided vital information. They were navigating unchartered waters and were able to create maps showing the coastlines, natural harbours and land masses. They were also able to document the weather conditions, including how they changed over the months. Contact was also made with the Inuit Eskimos, and once the trust had been established, there was the opportunity to learn more about whaling from the natives. Eventually, some of the Eskimos would visit Dundee – carried on the whaling ships – to allow them to experience the culture in the city.

By the 1830s the whaling industry was in decline, however. Competition from the American ships resulted in the waters being overfished, and the growing use of coal gas for lighting reduced the demand for the whale oil. While other ports saw the end of their whaling industry, Dundee did just the opposite thanks to the growing jute industry, which use whale oil to soften the natural fibres. By 1857, the jute mills were going through around 2,000 tons of whale oil, and a new fleet of whaling ships was being built. In the same year, the ship *Tay* was the first whaling ship to be fitted with steam engines, allowing it to travel to the Arctic quicker and to be more resilient to being caught in the ice flows. By 1867, Dundee had twelve steam whaling ships in operation, and by 1880, Dundee was the only remaining whaling port in the UK. At the start of the twentieth century, the decline of the jute industry in Dundee resulted in a decreasing demand for whaling. The introduction of mineral oil, which was substantially cheaper than whale oil, led to a further decline, and by 1914 the whaling industry in Dundee had ceased.

While whaling usually involved long, dangerous journeys, on one occasion this was not required, and the whale came to the whalers. The incident took place in December 1883, when a large humpback whale swam into the Tay Estuary. Unfortunately for the whale, the whaling fleet was docked for the winter months

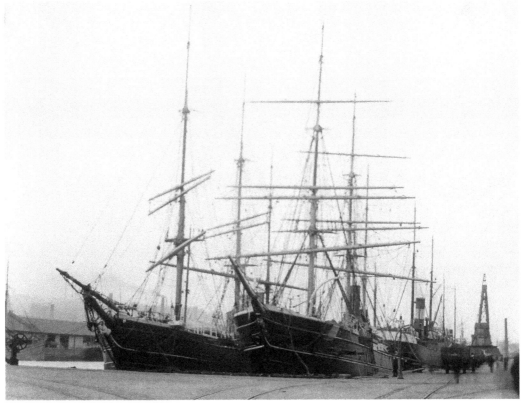

Ships at Dundee Harbour – *Discovery* and *Esquimaux*. (Courtesy of Dundee Heritage Trust)

and, not wanting to miss out on the opportunity, some quickly set sail to hunt the whale. It was harpooned but managed to escape back out to the North Sea when the rope snapped. A week later, the whale was found dead at sea, and was towed into Stonehaven harbour, where it was bought by John Woods, a Dundee whale merchant, who had it brought back to Dundee, where it was put on display. It is said that up to 50,000 came to see it, no doubt due to the stories the press had been running about it giving it names such as 'the Tay Monster'. After two weeks, with stench from the decaying carcass no doubt bringing any public viewing to an end, Professor Struthers from Aberdeen was invited to carry out an autopsy of the whale. The whale was then stuffed and taken on tour around the country, and eventually the skeleton was donated to the McManus Museum in Dundee, where it was exhibited until recently.

Whaling did, without a doubt, play a significant role in Dundee's past. It substantially boosted the shipping industry and provided the main ingredient to allow the jute processing to become the worldwide industry it grew to be. It was also a significant employer, creating up to 4000 jobs during its lifetime. There is no doubt however that it was a hard and dangerous job, with many men losing their lives due to ships being sunk or becoming stuck in the ice, and many more returning with illnesses

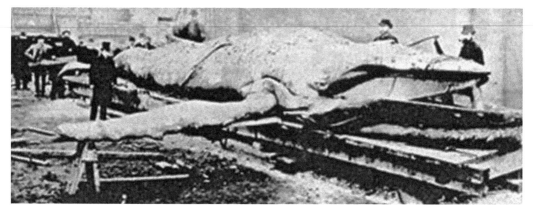

The Tay Whale.

or frostbite, often resulting in the loss of limbs. It is estimated that there are the wrecks of around forty whaling ships from Dundee lying beneath the ice of the Arctic whaling region.

BIOMEDICAL

Dundee is well known today as being one of the leading centres for biotechnology and biomedicine, and the city does, in fact, have a long history of making medical advances.

The connection between the city and medicine is possibly a reflection of the poor health suffered by many who were working in the dangerous industries of the time and living in appalling conditions. By the mid-1700s, several small medical establishments were operating and in 1782 a Public Dispensary for Dundee – that being a facility to offer medical advice and medicines either free or for a small charge – was established by Revd Dr Small and Mr Robert Stewart, surgeon. This was soon to grow, and a proposal was made to build an infirmary for the city, which led to the opening of the fifty-six-bed Dundee Infirmary on King Street in 1798, followed in 1812 by the building of a Lunatic Asylum on Albert Street. In 1819, the infirmary received a Royal Charter and became known as the Dundee Royal Infirmary and Asylum, and shortly after, in 1825, two wings were added to the building to meet the growing demand for its services. At the same time, plans were also being produced to extend the asylum. The ever-growing population of Dundee once again outgrew the facilitates and overcrowding was becoming an issue. When the asylum had been built it was out with the town, but the influx of industry and people had resulted in the development around the site, and further expansion was not an option. The Infirmary, best known now simply as the DRI, faced a similar problem, and in 1852 work on a new hospital on Barrack Road started, with it opening its doors in 1855. The asylum continued to struggle on, but

with growing demands on patient care in 1875 a new asylum was built on Cardean Street. In 1889, a separate fever hospital named Kings Cross was also built on Clepington Road.

The DRI continued to be expanded, with new buildings being built within the grounds, including accommodation for the nurses. A department for eye care was also established. In 1902, a wealthy jute mill owner, James Caird, gifted the money for a hospital for the treatment of cancer to be built, with a further donation for researching the disease. The Caird Pavilion for the treatment of disorders and diseases in children was also added and, in 1925, X-Ray facilities were brought to the hospital. In 1930, the maternity hospital opened. The hospital development had relied on donations from benefactors until 1948, when it was taken over by the newly formed National Health Service. A specialist neurosurgery department was set up in the 1960s and in 1970; the DRI became the first hospital in the UK to have a CAT head scanner.

It is important to remember that the DRI not only provided care and treatment for the population of Dundee and the surrounding area, but that it was also a teaching hospital. Through this, significant advances in medical care were made in areas such as allergies and immunity. Early methods for taking X-Rays were trialled

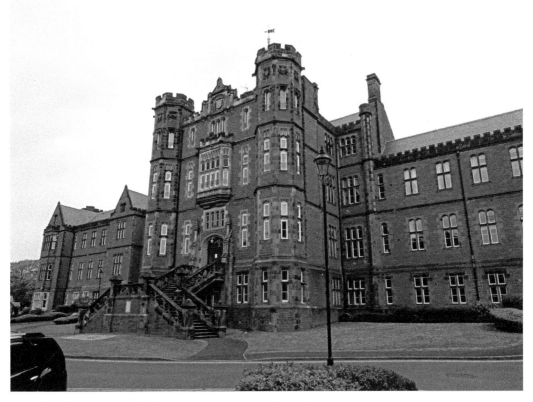

The Dundee Royal Infirmary, now converted into flats.

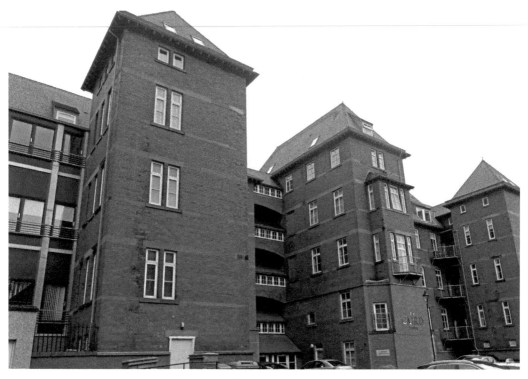

The distinctive red-brick buildings of the DRI, now converted into flats.

The remaining DRI buildings.

at the hospital as early as 1896, often at the great personal sacrifice of the doctors, who suffered badly from exposure to radiation. Research into cancer saw the first use of radium being used as a treatment in Dundee in 1913, and connections between pollutants such as smoke in the air and cancer being made in the 1930s. The Department of Cardiology was established in the 1920s and is now a centre of excellence recognised worldwide. Teaching at the hospital had been tied in with St Andrews University and later the University College of Dundee (founded in 1883), and in 1904 a new building to house the Medical School was opened at the University College of Dundee. In 1954, the University College became known as Queens College of St Andrews, and in 1967 a university charter was awarded to the college, which became the University of Dundee. An independent medical school was also formed as part of the university.

By the end of the Second World War it was recognised that the DRI building was becoming increasingly unsuitable to provide modern patient care and facilities, and considerations were turning to the creation of a new hospital. It was not until 1974 that these plans came into fruition and Ninewells Hospital opened. This new, 800-bed hospital was the first teaching hospital to be built in Britain since the nineteenth century, with the Dundee Medical School moving to the new premises. Ninewells continued to grow, and by 1986 the BBC Doomesday Reloaded project found that the hospital had 830 beds, fifteen operating theatres, treatment facilities

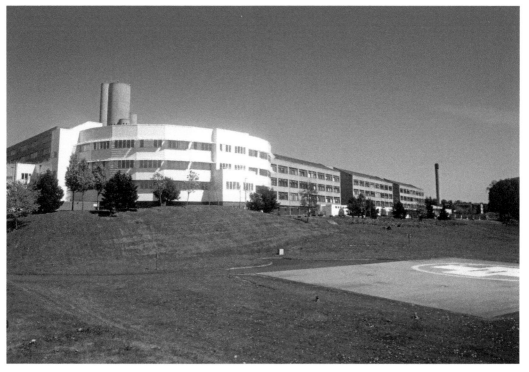

Ninewells Hospital.

for 960 patients and an unimaginable 25 miles of corridors. The hospital employed around 5,000 staff at that time. Ninewells had a major effect on the DRI and other smaller hospitals in the city, as increasing levels of care and research work were transferred. The DRI was closed in 1998.

Dundee has continued to go from strength to strength in the field of medical research. Ninewells is now one of the largest teaching hospitals in the UK, and the medical school has the following four distinct research divisions: Cancer Research, Molecular and Clinical Medicine, Neuroscience and Population Health Sciences. Study and research facilities have been created throughout the city. Dundee now has a larger medical research complex than the National Institute for Medical Research in London and around 20 per cent of the life science companies in Scotland are based in or around Dundee, which, in total with the support network and academic sector, create employment for around 4,000 people. The research is supported by Dundee University and the Abertay University, as well as the Dundee and Angus College and the James Hutton Institute, which drives the sustainable use of land and resources through applied science.

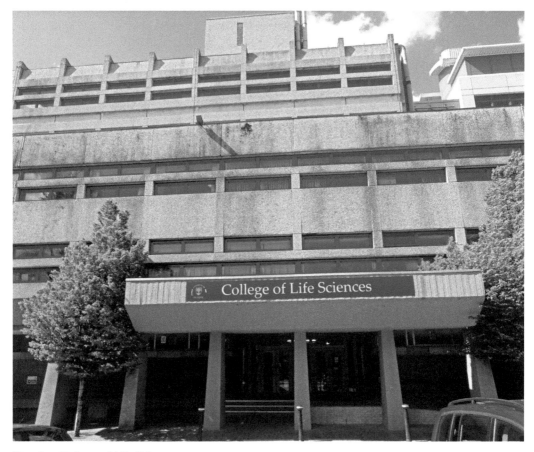

Dundee College of Life Sciences.

Dundee College of Life Sciences.

Abertay University.

The James Hutton Centre.

Maggies Centre at Ninewells Hospital.

NINETEENTH AND TWENTIETH CENTURY

The start of the Industrial Revolution brought new manufacturing process to Dundee, allowing the already existing industries to start to expand, and the nineteenth century brought boom times to the city, with rapid and massive expansions of existing and new commercial enterprises going into mass production.

JUTE

Jute is the first of the famous 'Three J's' of Dundee, although it actually arrived in the city after the Jam empire had started. Dundee was already established as a producer and exporter of linen, producing massive quantities of sail linen that was sent all around Europe. It was, however, the arrival of twenty bales of jute at Dundee's docks in 1820 that would see this industry expand beyond all expectations.

Jute is natural fibres from two varieties of plant from Bengal (now included as part of modern-day Bangladesh), and is extremely versatile and strong. The bales were tightly packed and said to have been as hard as wood, meaning the jute had to go through a process before it could be used, the first of which was to separate the jute fibres into bundles and soften them by spraying them with a mixture of water and oil. This is where Dundee came into its own as not only did it have the weaving mills that could be adapted relatively easily to process the jute, whale oil was readily available from the whaling industry and was the ideal product to use to soften the fibres. Combining these factors with the shipbuilding industry that was able to construct large, fast ships to bring the raw jute to the city, Dundee was the ideal match for the East India Company, which was seeking new markets for its jute.

Until the 1830s, jute was produced alongside other linen produce. However, it soon took over, leading Dundee to earn the nickname 'Juteopolis'. The jute mills were concentrated in the Blackness and Lochee areas of Dundee due to the locality of a water supply for the steam machinery, as well as along the banks of the Dens burn, for the same reason.

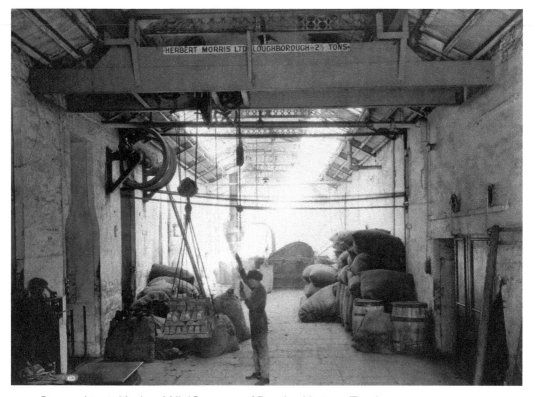

Boy working in Verdant Mill. (Courtesy of Dundee Heritage Trust)

Some linen mills outside these areas were relocated and other businesses in the areas, such as former leatherworks, were converted into jute mills. The versatility of the jute allowed a long list of products to be made, ranging from boot linings, sack and rope to ships sails, tents and tarpaulins. Such was the strength of the jute products, the sails for the Royal Research Ship *Discovery* were made at the Dundee mills, and were able to withstand the harsh environment of Antarctic exploration. The height of the jute production was between 1860 and 1870, when there were over 100 mills in the city employing an estimated 50,000 people – around half of the working population of the city. The Camperdown Works at Lochee was one of the largest jute mills in the world, occupying a 34-acre site with its own foundry and branch railway, employing around 5,000 people.

Although jute brought mass employment to the city, it also brought considerable social change. While most of the mill workers lived in poverty, the jute barons had grand mansions built, with Strathern Road in Broughty Ferry becoming known as 'Millionaires Mile' and deemed to be the richest mile of real estate in the world. There was also a significant role switch for the families of the workers. With women outnumbering men working in the mills by three to one, the men started to stay at home to look after the children, earning them the nickname 'the kettle boilers' and the city becoming known as 'She-Town'. Work at the mill was hard and physical, bringing a hardened nature to

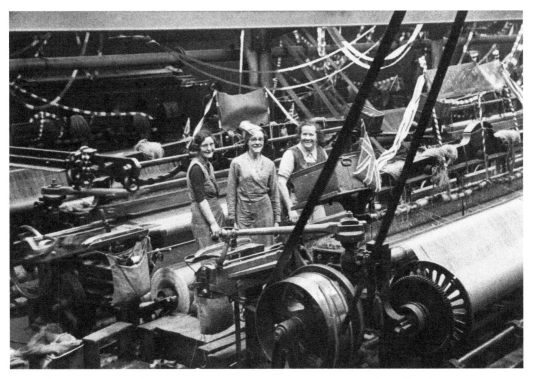

Three women standing among looms. (Courtesy of Dundee Heritage Trust)

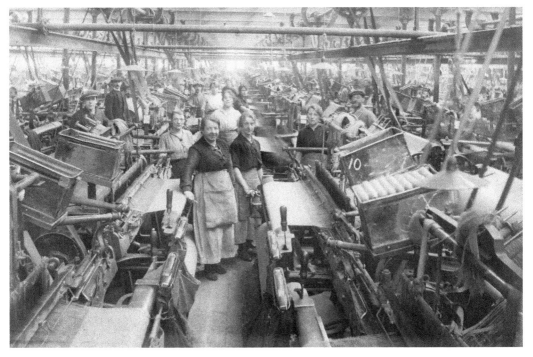

Weaving in unknown Dundee factory *c.* 1910/11. (Courtesy of Dundee Heritage Trust)

the women who, as the main wage earner, became more confident and outgoing. It is reported that they were often overdressed, loud and frequently drunk – something that was frowned upon by their husbands! The work also had severe effects on the health of the workers. The constant noise from the machinery caused many to lose their hearing, and the dust and dirt brought respiratory problems. A massive influx of people to the city seeking work, all wanting to live close to the mills, caused severe overcrowding and sanitation problems. The demand for housing drove the cost of living up, while the ready supply of workers drove the wages down. As evidence of the appalling living conditions, in 1863 the average life expectancy for a man in Dundee was just thirty-three years, and in 1904 around 50 per cent of the men volunteering to join the Army were refused by the local recruiting office as they were deemed unfit for service.

While the jute barons had made their fortunes from the industry in Dundee, it was the same jute barons who started the decline by establishing mills in India at the start of the twentieth century. By 1920, jute production in Dundee was in serious decline due to the competition. There was a boost in the demand for products during the First and Second World Wars; however, after 1945 production slumped again. The jute mills remained the largest employer in the city until the 1950s, but the introduction of synthetic materials to the market brought further decline, and in 1989 the Taybank Mill, the last working mill in the city, was closed.

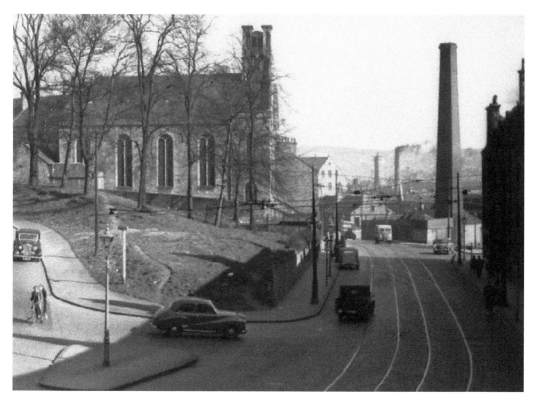

A general view over Dundee from Lochee Road showing the Jute Mill chimney stacks.

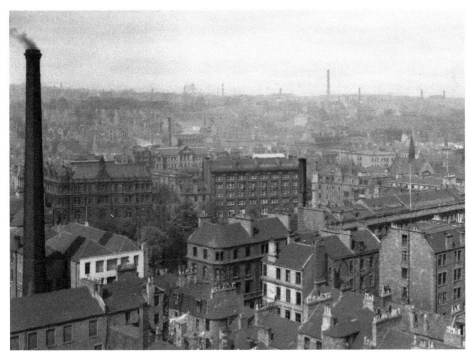

A general view over Dundee city centre showing the numerous Jute Mill chimneys stacks.

The South Mill, Brown Street.

Above: Logie Works (also known as the Coffin Mill due to its unusual shape).

Left: The Lindsay Street mill.

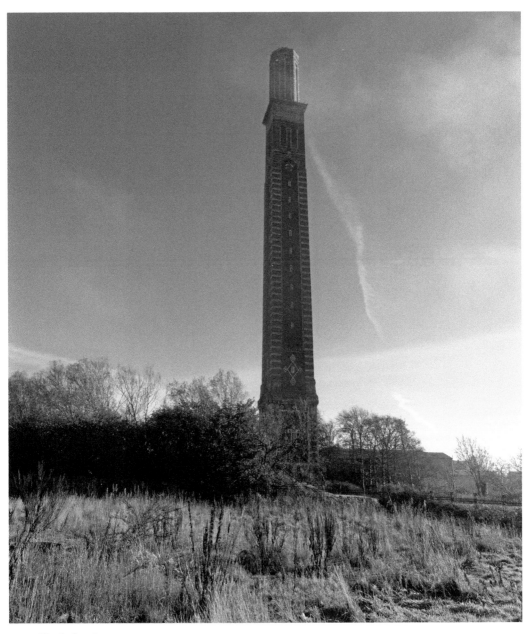

Cox's Stack.

Most of the jute mills have since been demolished, although some have been converted to housing and offices. The Verdant Works, built in 1833, has however been saved due to the good fortune that despite being used as offices since around 1970, no modernisation work had been carried out to the mill. It was purchased in 1991 by the Dundee Heritage Trust and opened as a museum in 1996, giving a real insight into the working environment for the mill workers.

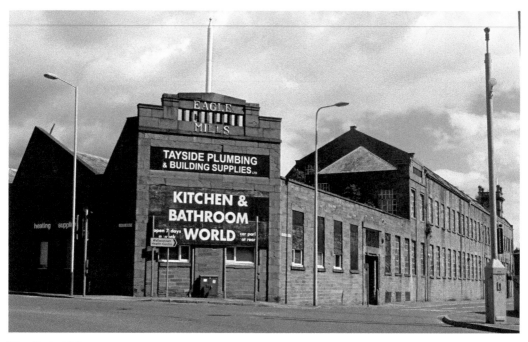

The Eagle Mills.

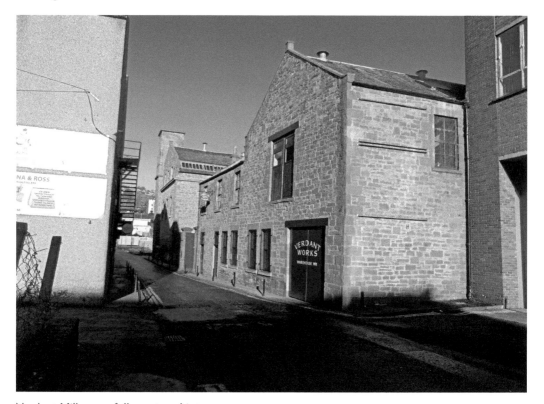

Verdant Mills, now fully restored into a museum.

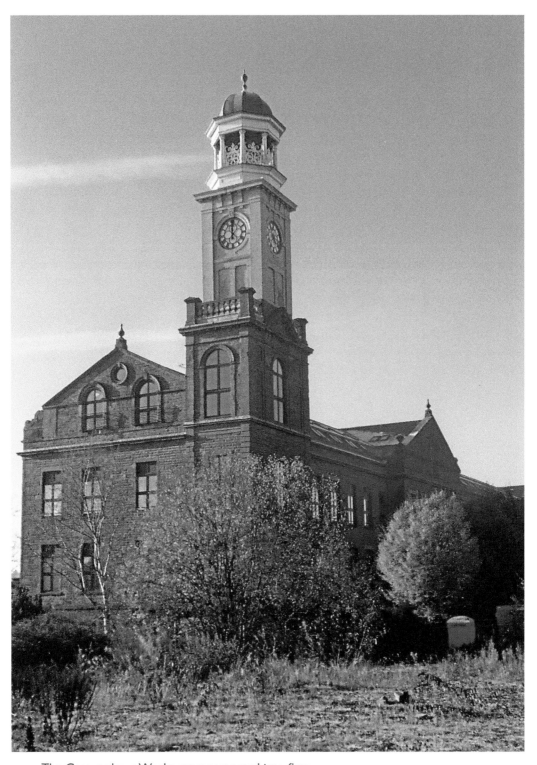

The Camperdown Works, now converted into flats.

JAM

The second of the 'Three J's' that Dundee is famous for was jam, or more precisely, marmalade. Although the company started in the late eighteenth century, I have kept it in this chapter as the majority of the growth and trading took place in the nineteenth century, and it keeps the Three J's together. The establishment of the Jam empire in Dundee is credited to Janet Keiller, who is often referred to as the inventor of marmalade. However, this is not correct as recipes had been around for a long time prior to Janet's involvement. It was, however, the type of marmalade created by Janet that was a first, and helped establish the company.

Born in 1737, Janet Keiller ran a successful small shop in Dundee along with her husband John, selling cakes, sweets and fresh fruit. There are varying stories regarding how their brand of marmalade came about, the most common being that a Spanish ship had sailed into the Tay estuary seeking shelter from stormy weather. Within the cargo was a batch of Seville oranges, which were already starting to go off due to the long journey. Knowing that the further delay would almost certainly result in the oranges being worthless, the ship's captain offered them for sale, and they were bought by John Keiller. Knowing the fruit was already bitter, the captain no doubt was happy to have offloaded the effectively worthless consignment, but John knew a bargain when he saw one. He gave the oranges to Janet to see what she could do with them and she set about trying different recipes to make an orange preserve. What was different about her blend, and set it apart from other marmalades of the time, was that she included orange peel in her mix. This is where the belief that Janet invented marmalade originated; in fact, she created the first marmalade to contain the rind of the fruit, known as 'Chip Marmalade'.

Another version of the story, although unlikely but humorous, was that it was Janet's son, James, who discovered the oranges that had been washed up on the beach having been dumped overboard by the ship's captain. He took some home to his mother who, after coming up with her mix for her preserve, shouted to James to return to the beach and get 'mair, ma lad', so she could make larger batches, and it was from this shout that the name 'marmalade' originated.

The Keillers began to sell their marmalade in their store in the Seagate area of the city, and it quickly became a success. In 1797, along with her son, Janet formed a company initially named James Keiller, before changing to James Keiller and Sons in 1804. Janet remained involved in the business, with James relying on her expertise until her death in 1813, and although the success of the company continued under his leadership, it was not until after his death in 1839 that it began to grow into the worldwide enterprise that it became. The business was taken over by his wife, Margaret, and son, Alexander, and between them they started a programme of growth. In 1845, they moved the company to two neighbouring properties at Castle Street, creating a store and a workshop.

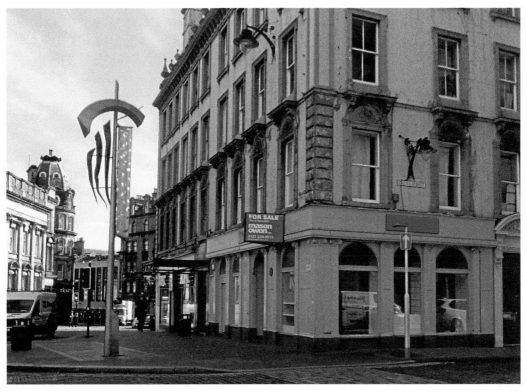

The property at the corner of Castle Street that was occupied by Keiller from 1845.

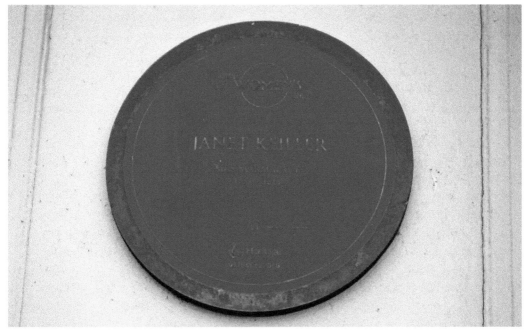

A memorial plaque to Janet Keiller, or 'Mrs Marmalade', at the Castle Street building.

The former premises in the Seagate were converted into a production factory, introducing steam machinery to boost the volume of marmalade being manufactured, creating the first commercially produced marmalade. A dedicated bakery department was also established. Due to the sugar tax on the mainland at the time, a factory was also set up in Guernsey to cater mainly for the worldwide market and to better serve the south of England, although the marmalade still bore the Dundee name. The bakery side of the company also expanded, and when the Seville oranges were out of season, the preserve side of the business concentrated on producing jam and confectionery. Around 150 people were employed in the production, rising to 200 during the marmalade season, mainly women, however, as the confectionery side of the business grew, so too did the workforce and by 1869 around 300 people were employed and was the largest confectioner in Britain.

The abolition of the sugar tax in 1870 saw the Guernsey production line move to London and a further growth of production in Dundee. A new, larger factory was opened in Albert Square in Dundee, very close to the existing shop to ensure a steady supply. By 1914, the company had grown considerably, employing around 2,000 people throughout their various production plants, with around 800 in Dundee. In 1918, James Keiller and Son was purchased by Crosse and Blackwell, the largest food production company in the British Empire. Keiller continued to operate under its own name, and with up to 20 per cent of the UK jam market, by 1921 it was considered to be the largest preserve company in the world. A new bakery plant was opened in Mains Loan, Dundee, in 1928, and they claimed to be the original creator of the Dundee Cake, which quickly became the bakery's top seller, closely followed by their shortbread. By 1931, Keiller had been made official supplier of marmalade to the king and chocolate to the queen, by royal appointment and also produced a large number of other well-known confectionery items, including Toblerone. By 1946, they operated a number of baker stores throughout the city under their own name and by 1950 shortbread had become the company's largest export.

A number of subsequent takeovers saw Keiller lose the licence to produce Toblerone, and with fierce competition worldwide, they saw their fortunes decline. By 1980, although they remained in the top six confectionery companies in the UK, they only employed 320 people in Dundee and plans were made to shut down the loss-making factory. A local entrepreneur stepped in to save the company, albeit with a further reduced workforce. They successfully turned the company around and once again brought it back into profit. With the company once again changing hands several times, production of preserves finally ceased in Dundee around 1988. The confectionery side of the business, however, continued, with Alma Holdings taking ownership around the same time. Alma invested considerably in the Dundee plant and moved their headquarters to the city, until financial difficulties once again hit the company and it was purchased by Craven of York, who rebranded

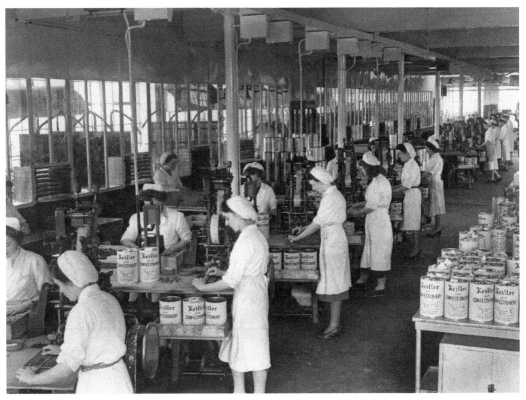

Workers wrapping confectionery in the Keiller factory around 1950. (Photo used by kind permission of DC Thomson & Co. Ltd)

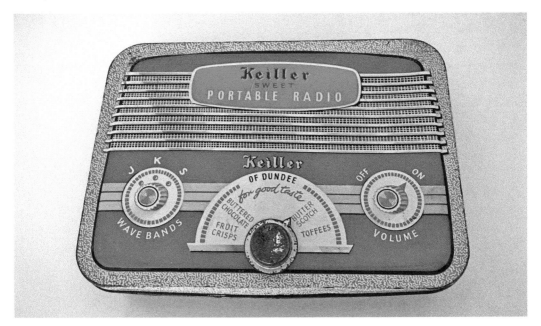

An example of a Keiller biscuit tin from around 1950.

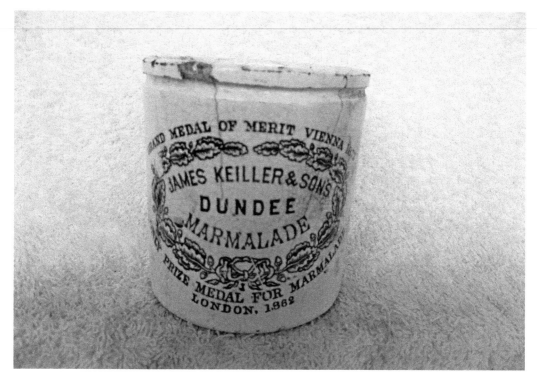

An early Keiller marmalade pot.

The Keiller factory on Mains Loan in 1992. (Photo used by kind permission of DC Thomson & Co. Ltd)

The Keiller factory on Mains Loan today.

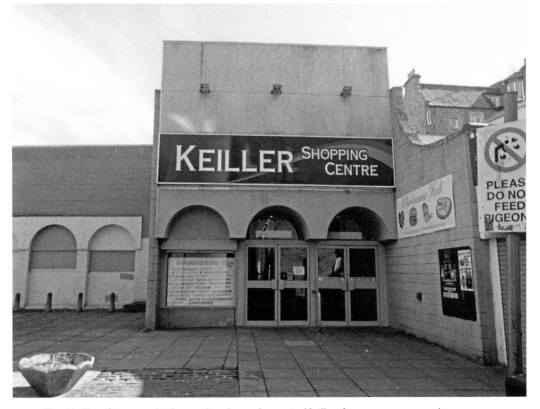

The Keiller Centre, which stands where the main Keiller factory once stood.

as Craven Keiller. This was, however, the beginning of the end of production in Dundee, and the Keiller brand name now only remains in marmalade made for the export market only.

Although the Keiller brand may have left Dundee, the name lives on in the city, with the Keiller Centre occupying the site of the former factory at Albert Square.

JOURNALISM

The third of Dundee's 'Three J's' relates to journalism, and primarily the success story of D. C. Thomson. However, Dundee has had a long history of printing and journalism that predates this famous company.

The first weekly newspaper printed in Dundee is believed to have been the *Weekly Intelligencer*, which was published by Henry Galbraith and Co. from 1755. The history of the company is somewhat scant, and it is not clear how long they operated, although it does seem that the publication of the paper had a relatively short life. While other small printers established themselves in the town, it was not until 1775 when Thomas Colville started a printing business that Dundee would become a major player in the world of journalism. Coleville printed several newspapers, yet it was after they started to print *The Dundee Weekly Advertiser* and *Angus Intelligencer* that they took their first steps into journalism when, in 1809, they established a rival newspaper, named the *Dundee Mercury*. The rivalry continued for seven years and saw the *Dundee Advertiser*, as it was by then known, come out on top, and Colvilles returned to be solely a printworks. In 1816, Colvilles made a further move into journalism, and on 20 September the first copy of a new newspaper named *The Dundee Courier* rolled off their printing press. *The Courier*, as the paper is better known, passed through several other publishers over the following years until, in 1886, William Thomson, who operated a local shipping company, along with his son, David Couper Thomson, purchased the printing firm Charles Alexander & Co., and with it they became the owner of *The Courier*. In 1905, the Thomson company merged with the only other major publisher in the city, John Leng and Co., and under the leadership of David Couper Thomson, it went on to become the publishing dynasty that it is today.

Locally, D. C. Thomson is still well known for publishing *The Courier*, now a daily newspaper available in four separate regional editions. They are, however, behind many other publications known both nationally and internationally. D. C. Thomson are the publishers of *The Sunday Post*, a weekly paper founded in 1914, which remains one of the largest sellers in its readership area of Scotland and northern England, and is also responsible for bringing us two of the best-loved comic strips in the country – The Broons and Oor Wullie, both of which celebrated their eightieth anniversary in 2016.

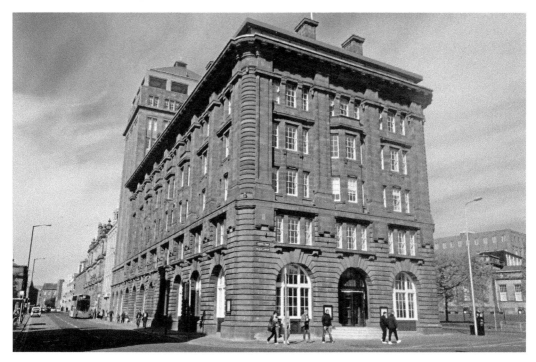

The Courier Building at Albert Square.

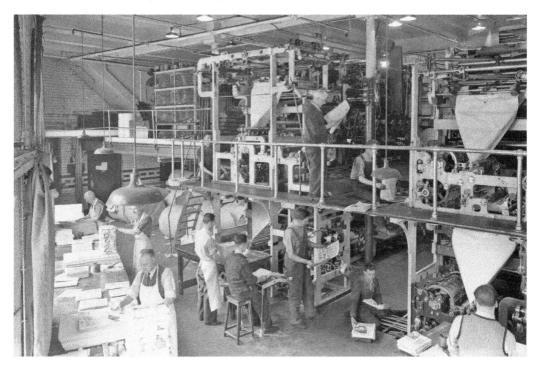

The Stereo Department for DC Thomson *c.* 1952. (Photo used by kind permission of DC Thomson & Co. Ltd)

Inside the Courier Building Press room *c.* 1954. (Photo used by kind permission of DC Thomson & Co. Ltd)

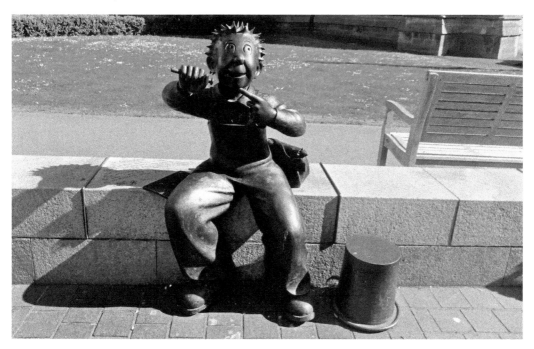

A bronze statue of Oor Wullie unveiled in 2016, sitting on the wall outside the McManus Galleries on Albert Square firing his pea shooter towards the statue of the poet Robert Burns.

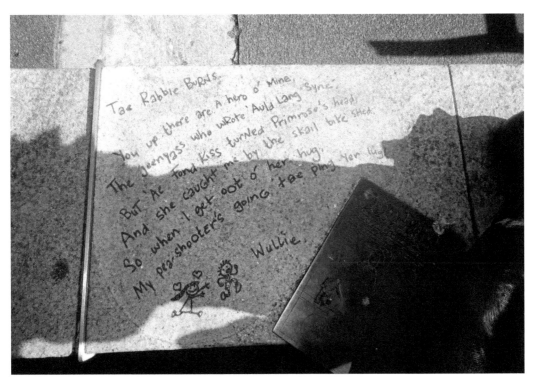

Writing in Oor Wullie's school jotter that sits beside him in Albert Square, with a poem about what he is doing.

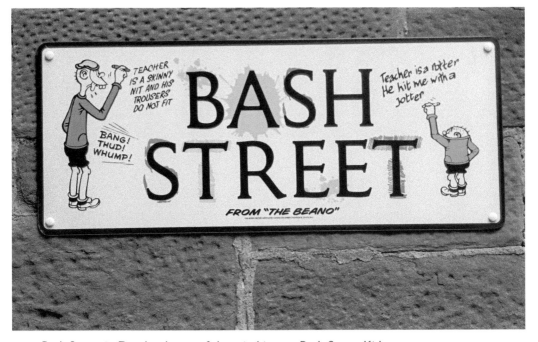

Bash Street in Dundee, home of the mischievous Bash Street Kids.

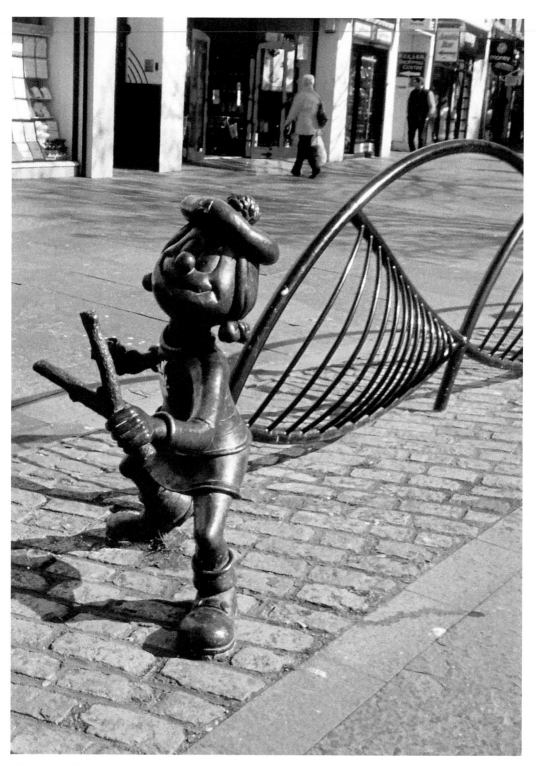

Minnie the Minx statue in the City Centre, unveiled in 2001.

D. C. Thomson is also behind the best-known comics in the country. *The Dandy*, first published in 1937, introduced instantly recognisable characters such as Korky the Cat and Desperate Dan, and the *Beano*, first published in 1938, with Dennis the Menace, The Bash Street Kids, Roger the Dodger, Minnie the Minx and Billy Whizz.

Other characters were added later (some from other comics), such as The Numskulls (originally published in the *Beezer*), Beryl the Peril (originally published in the *Topper*) and Bananaman. The last edition of *The Dandy* was published on 4 December 2012, the seventy-fifth birthday of the comic, but some characters still live on in the Beano, which continues to be printed and is now the longest-running British children's comic. Some characters have gone on to be made into television cartoons, such as Dennis the Menace and Bananaman.

The success of D. C. Thomson is, at least in part, due to the ability of the company to adapt to the ever-changing demands of the consumers. As well as producing traditional newspapers and magazines, the company has kept up to date with current trends and technology, producing magazines such as *110% Gaming* for the younger video

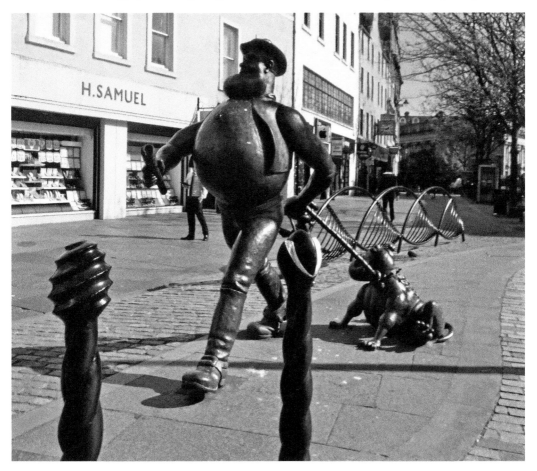

Desperate Dan statue in the City Centre, unveiled in 2001.

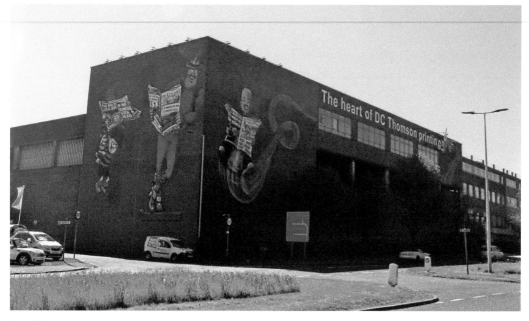

DC Thomson & Co. Ltd premises on the Kingsway, depicting several of their favourite characters.

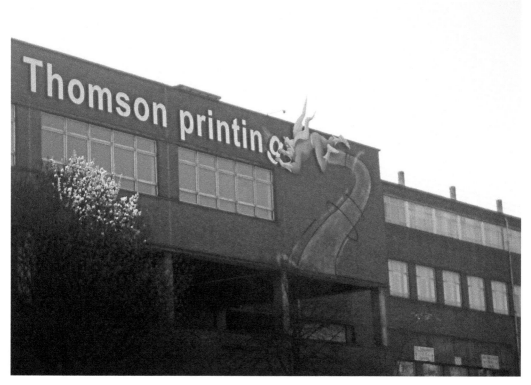

Bananaman 'fixing' the sign at the Kingsway premises of DC Thomson & Co. Ltd.

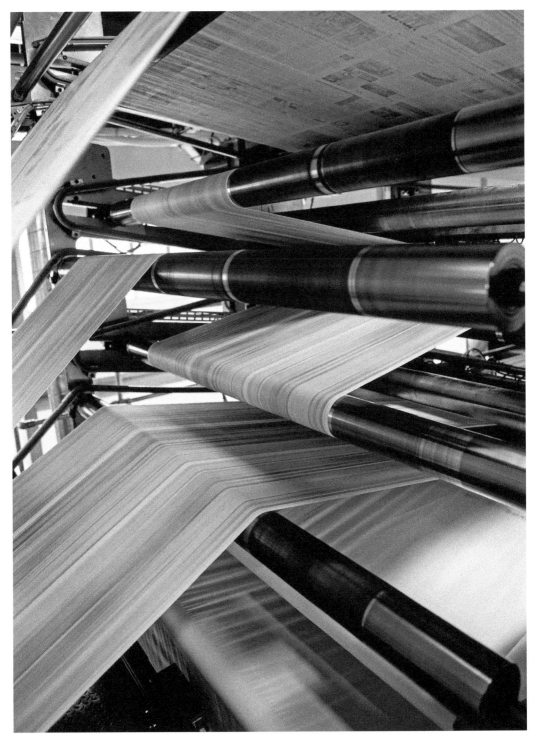

Newspapers passing through the printing presses at DC Thomson. (Photo Used by kind permission of DC Thomson & Co. Ltd)

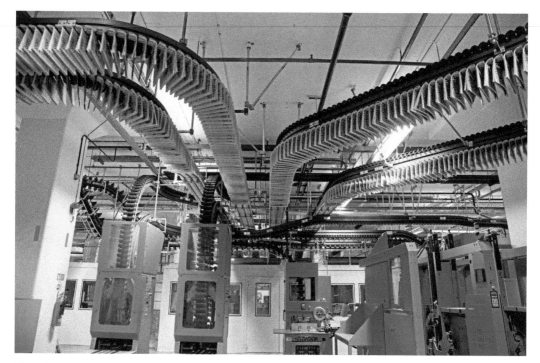

The Discovery Print Mailroom at DC Thomson. (Photo Used by kind permission of DC Thomson & Co. Ltd)

games market. They have also moved into digital technology, launching the world-leading online genealogy brand Findmypast, the first company to provide complete access to birth, marriage and death records for England and Wales. Findmypast is the lead of several online brands, with around 18 million registered users. The company still employs around 2,000 people today at its various premises across the UK.

VALENTINES

The Valentines card factory became a well-known sight for drivers on the Kingsway for several decades, yet the company was created almost a century before its construction.

John Valentine initially established the business in Dundee around 1825, engraving wooden blocks that were used to add print to the linen being produced in the linen factories, before moving to also offer engraving on steel and copper. In 1837, the business moved to new premises in the Overgate and also began to produce printed stationary. By this time, John's son James had joined the business, although in 1840 the decision was made for them to start to operate separately from each other and John began to trade under his own name. Around 1850, John Valentine decided to concentrate solely on the production of wooden stamp blocks, and

the lithographic side of the business was taken over by James, who had studied photography at St Andrews University.

Operating from a premises in the Murraygate, James added portrait photography to the commercial interests of his business and by 1878, as demand for his work grew, he had moved to larger premises on the Perth Road. In 1860, he had expanded the business to include landscape photography, and it was when some of his works caught the attention of Queen Victoria that the business had really taken off. Victoria commissioned around forty scenes depicting the Highlands of Scotland, and James was appointed 'Photographer to the Queen'. James Valentine died in 1879, after which the business was known as James Valentine and Son, with his sons William and George taking over the operation.

Having expanded the business at the end of the nineteenth century to include the production of postcards using real photograph images showing landscapes and townscapes, the company had grown to employ around 1,000 people. They soon went global, with offices in the USA, Canada, South Africa and Australia. In 1925, they moved into producing calendars and greetings cards. The Kingsway factory was built in the late 1930s to accommodate the business. It would grow to become one of the largest card manufacturers in the country.

The building occupied by Valentines on the Perth Road. The buildings behind have now been demolished.

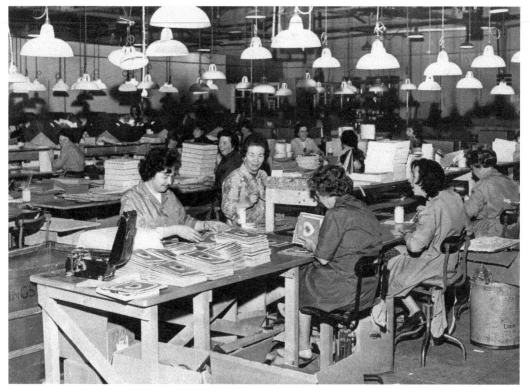

Women working inside the Valentines factory around 1964. (Photo used by kind permission of DC Thomson & Co. Ltd)

In the early 1960s, Valentines caught the attention of John Waddington Ltd, the games manufacturer that had brought classics such as Monopoly and Cluedo to the shops. Waddington's had started as a printing company before moving to producing board games, and in 1963 they purchased Valentines. In 1980, the company changed hands to the card maker Hallmark Cards, and by 1990 was producing an estimated 60 million cards a year, which were then shipped all over the world. Despite the massive number of cards being produced, the factory only employed around 430 staff – no doubt as a sign of the developing technology in production, and a sign of things to come. The downward spiral for Valentines was rapid, and just a few years later, in 1993, around half the staff were made redundant. The following year, Hallmark merged with the Andrew Brownsword Group, and the doors of the Valentines factory in Dundee closed forever.

The factory stood empty for many years before being demolished, with various proposals being submitted to redevelop the site. Today, a new car supermarket has been built on the site, bringing employment back to the area.

After the closure of the business, St Andrews University purchased the archive of monochrome images dating from 1851 to 1967 (when the use of monochrome images ceased). The collection totals over 120,000 and is not the complete

collection, which gives an idea of the number of photographs used by Valentines. Thankfully, this has preserved the bulk of the work carried out by Valentines over the years. The images are held by the Special Collections Division of the university library and can be viewed by the public.

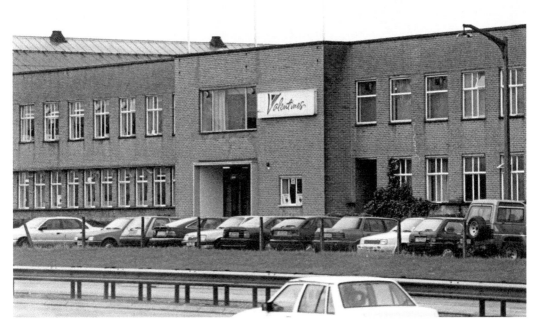

The Valentines factory just off the Kingsway around 1994. (Photo used by kind permission of DC Thomson & Co. Ltd)

The new car showroom that now occupies the site of the former Valentines factory.

POST-SECOND WORLD WAR

Like many industrial cities in the UK, Dundee suffered badly during the depression of the 1930s, and while it did have a resurgence in some of the industries during the Second World War, such as shipbuilding, these industries began to dwindle again afterwards. Dundee was not, however, to be beaten, and the city made it be known that it was open for business. While some industries already discussed – such as the shipping and biomedical industries – adjusted and adapted, with land available and industrial units being constructed, new businesses were also being attracted to the area.

NCR

After the Second World War, there was a push to encourage new businesses to come to Dundee. With the city having a long-held connection with engineering, it began to adapt to cater for the new technologies. One of the first companies attracted to the city were the American giants National Cash Registers, or NCR as they are more commonly known (although many in Dundee refer to the company simply as 'The Cash').

Originating from Daytona, Ohio, in 1879, NCR had originally been known as the National Manufacturing Co. The company was established to manufacture and sell the first mechanical cash registers, and it is from this that the company took their new name when it was sold in 1884. The new company employed a sales force across America, who by selling the security benefits of the mechanical registers to the storekeepers, significantly aided in the growth of the company until it held almost all of the American market and was selling internationally. During the First World War, NCR manufactured aircraft instruments and fuses and during the Second World War they were involved in making aircraft engines and code-breaking machines. The company then went on to manufacture new computing and communication technologies in the post-war years.

It was at this time that the company sought to expand further. Local lore tells that when their scout saw pheasants fly from the potato field on the edge of Dundee, which he was

looking at as a possible site, he felt so uplifted that the deal was sealed. Staff from the company's office in London moved up to a rented mansion house on the Perth Road, a property that would go on to become the training school for new staff, while a purpose-built factory was constructed on the potato field site.

The NCR Camperdown site opened in 1946, with the production of cash registers based on the American methods. Within twenty years, the company had a total of six factories in the city, employing around 4,000 people, increasing to 6,000 by the end of the 1960s, making it the largest single employer at that time.

Everything started to change in the 1970s however, and wider competition saw the workforce decline to around 1,000 by the end of the decade. Around this time, the company changed the focus of manufacturing in Dundee, and the factories were adapted to develop and build the latest technologies including the Automatic Teller Machine. Dundee became the hub of ATM manufacture in the UK and employment numbers once again rose, this time not just for production staff but computer engineers and programmers to deal with the ever improving technology. The competitors again started to catch up and NCR again started to see demand decline. The flagship factory at Camperdown changed hands in 1986 and was occupied by Van Leer Tay for the production of large plastic bagging, and then part

The training base for NCR on the Perth Road.

The Van Leer building at Camperdown showing the front and side elevations in 1997. (Photo courtesy of The Scottish Civic Trust)

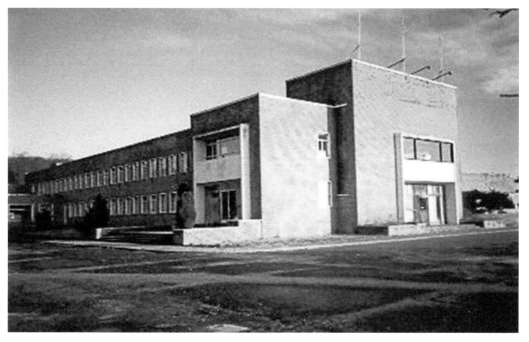

The Van Leer building at Camperdown showing the front and right elevations in 1997. (Photo courtesy of The Scottish Civic Trust)

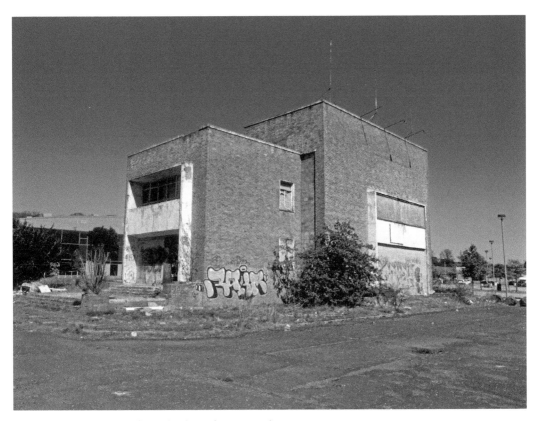

All that remains of the Van Leer factory today.

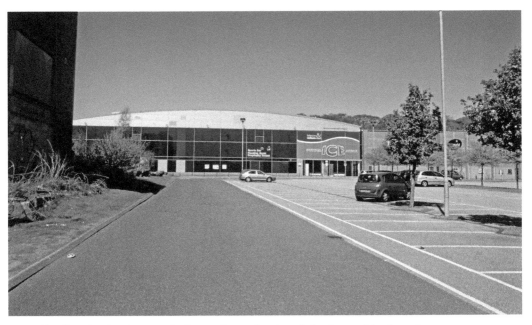

The Dundee Ice Arena, which stands on the site of the former Van Leer factory.

The current NCR premises on the Kingsway.

occupied by General Accident Insurance while awaiting the construction of their new offices. Growing competition and cheaper manufacturing costs abroad led to NCR announcing in 2009 that the production of ATMs in Dundee was to cease.

The company does, however, remain in the city to this day at their premises on the Kingsway, employing around 450 to 500 staff, concentrating on software development, research and the development of new products.

TIMEX

As with NCR, the offer of a prime site on the outskirts of the city lured the UK branch of the watch manufacturer United States Time Corporation to Dundee in 1946. The company had started in America in 1854, trading as the Waterbury Clock Co. Initially manufacturing just clocks and using brass mechanisms, the company soon developed their own design of oversized pocket watches. These caught the attention of a salesman named Robert Ingersoll, who marketed the watches before forming his own company, the Ingersoll Watch Co., which sold the watches while the United States Time Corporation continued to manufacture them.

It was during the First World War that the company moved to manufacture wristwatches when they became the watchmaker for the American Army in 1917. To meet the requirements for the Army, one of the small Ingersoll ladies pocket watches was re-tooled to attach to a wrist strap for the military, and following the war, in the 1920s, the watch became increasingly popular with the general public. In the 1930s, the company began to produce the now famous Mickey Mouse watch, which became the companies' first million-dollar wristwatch, saving the business from the worst effects of the Great Depression. During the Second World War, the company was bought over by Thomas Olsen and Joakim Lehmkuhl, and the manufacturing side of the industry was converted to produce mechanically timed artillery and anti-aircraft fuses to aid in the conflict. In 1944, the company was rebranded as the United States Time Corporation and in 1946 it was announced that the UK division was to construct a watch and clock factory on a 44-acre site in Dundee. Shortly after, a range of watches designed for nurses was produced under the name Timex, with the letter 'X' being added the word 'Time' to illustrate the technological advances the company was making in watch manufacture. In 1969, the Timex brand was so successful and internationally recognised that the whole company was rebranded.

The manufacturing in Dundee was a massive success. A 36,000 square foot factory was constructed on the site, which opened in 1947 employing 500 people in highly skilled jobs.

The intricate work required for operating the weaving looms was credited, to a certain degree, with providing staff with the expert hand-eye co-ordination needed to put the timepieces together, and the workers enjoyed good working conditions, pay and training, and the company grew. Over the following decades, two additional factories were built – one at Milton of Craigie and the other at Dunsinane Avenue – and by the late 1960s the Dundee plants were the largest suppliers of watches in the UK. By the 1980s Timex was the largest single employer, with over 6,000 staff. As a sign of the quality of the staff to the Dundee facilities, the factories were relatively unaffected during the initial stages of employment moving overseas by taking on development and production work for other companies such a Polaroid cameras. In 1981, the Timex factory was one of the first to move into home computer manufacture when they started to produce the ZX-81 for Sinclair Computers. The company could not, however, survive the changing times indefinitely, and the impact was to have destructive consequences for the city.

In 1988, production had fallen to a level where the factory in Milton of Craigie was closed and demolished, and in 1991, the Dunsinane Avenue plant suffered the same fate. In 1993, with the threat of further job losses, the workers went on strike. After an initial period of around two weeks, the employees offered to return to work while negotiations carried on. However, when the employees arrived, they found the factory gates to be locked, and the dispute turned increasingly bitter. Things got worse when Timex brought replacement workers into the factory by

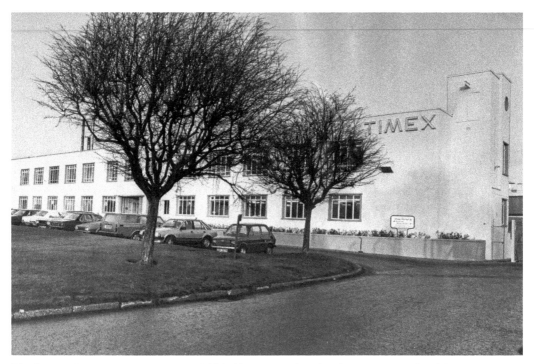

The Timex factory exterior around 1982. (Photo Used by kind permission of DC Thomson & Co. Ltd)

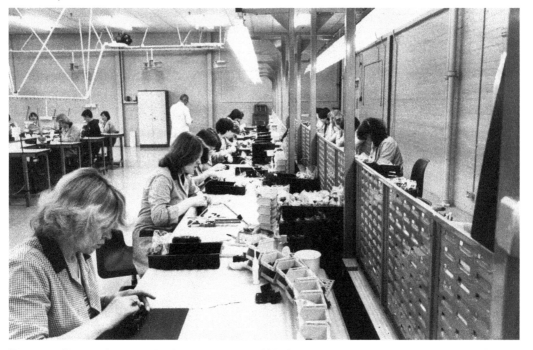

Timex staff at work inside the factory around 1982. (Photo used by kind permission of DC Thomson & Co. Ltd)

bus, to ensure they made it across the picket lines. With tensions running high and thousands of workers forming the picket lines and marching through Dundee, despite police being drafted in from all over to try to control the situation, things eventually turned violent. The following months were one of the darkest times for industry in Dundee, and it was the end for Timex, with the factory closing its doors in August 1993.

The last remaining factory, which was the first one built, did not suffer the same fate as the others, and in 1995 it was taken over by the JTC Furniture Group. JTC was formed in 1986, but their success resulted in them outgrowing their factory facilities on Baxter Street, and the move to the former Timex factory allowed them to start to manufacture fitted kitchens and bathrooms, along with fitted bedrooms and specialist furniture for the education and healthcare markets. Today, the company employs to around 300 people.

Despite it being over two decades since Timex left the city, the memories remain and the road leading up to the factory site is still unofficially known as 'Timex Brae' locally.

The Timex factory, now occupied by the JTC Furniture Group.

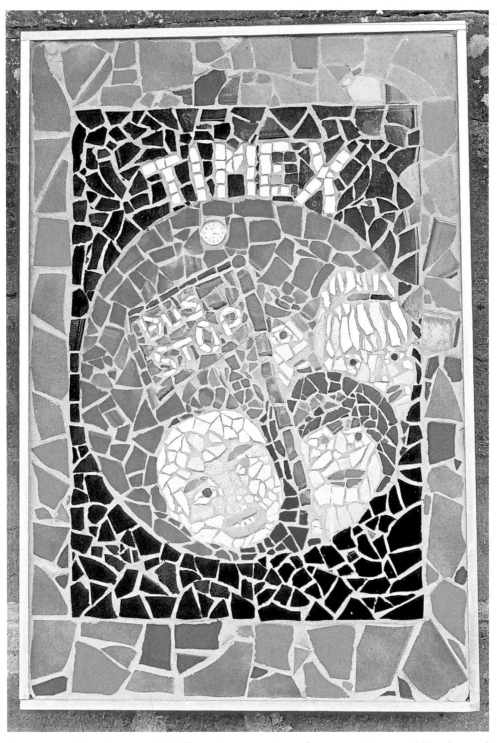

A mosaic marking the spot of the Timex bus stop where factory workers would be dropped off and collected.

The entrance to the former Timex factory.

The watch that forms the centrepiece of the bus stop mosaic.

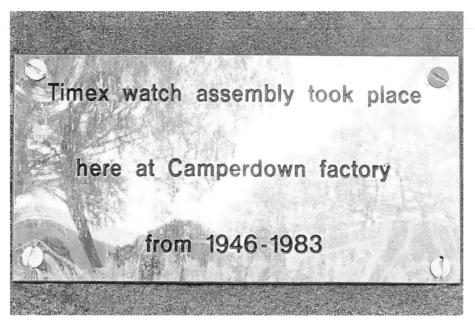

A plaque commemorating the role of Timex.

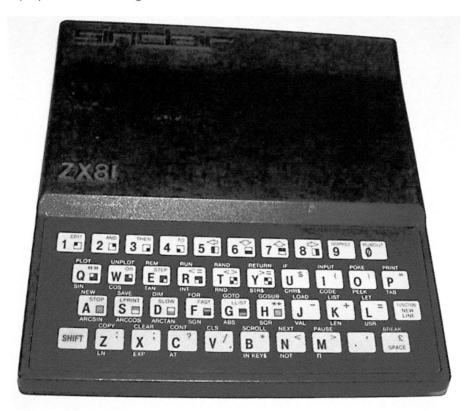

The Sinclair ZX-81, the first home computer easily accessible to many households.

LEVIS

In 1972, the American jeans and clothing company was set up in Dundee – one of four operations Levi had in the UK. With the jute industry in the city on its last legs, the timing was perfect for a lot of hard-working female workers with nimble fingers from working in the mills to take up new roles in the jeans wear factory, and it quickly grew to become a major employer. Within a relatively short space of time the company moved to a 55,000-square-foot production factory in Kilspindle Road.

Despite the impression many people may have of global giants, the company by all accounts established excellent relations with local communities, raising thousands of pounds at regular charity events. Staff relations were also reported to be excellent, with good working conditions, a bonus scheme and incentives for good attendance. At the height of its production, the factory employed up to 700 people producing around a million pairs of jeans a week.

Unfortunately, despite everything seeming so good for so long, changing customer purchasing trends and cheaper production costs from outside the UK soon spelled the

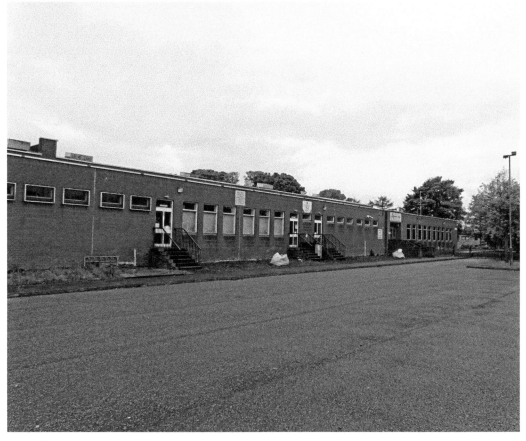

The former Levis Strauss factory.

beginning of the end for the manufacturing factories. Dundee survived the first wave of cuts in 1999 when proposals were made to close the sewing factory at Whitburn, near Edinburgh, and to cut jobs at their other plants in Scotland. In 2002, however, the inevitable happened, and with the company cutting around 10,000 jobs worldwide, the Dundee factory was closed with all staff being made redundant. Even now, more than a decade after the closure of the facility, many people who either worked at Levis or were involved with them through their community work still hold the company in high regard, no doubt a reflection on the work they did in Dundee.

MICHELIN

Michelin is known worldwide as one of the biggest tyre manufacturers, which grew from humble origins. The company originally made farm equipment and rubber balls from a factory in Clermont Ferrand, France, before starting to develop rubber brake pads. In 1891, the company was operated by two brothers, André and Edouard Michelin, who came up with a design for a detachable cycle tyre. Prior to this, tyres had generally been fixed to the wheels, making it very difficult to fix in the event of a puncture or to get a good seal again. A patent was obtained on the design and by 1895, the brothers had developed a tyre for a car to run on. In order to convince a sceptical public, who were used to cars running on solid wheels, they went a step further and developed their own car, named L'Eclair. The car was the first ever to run on pneumatic tyres, and to demonstrate the durability of their design, the brothers entered the Paris-Bordeaux-Paris race of 1895, where it covered 1,200 kilometres. The future of both rubber car tyres and the company was secured. With the success of their tyres taking off, despite the relatively low number of cars around at that time, Michelin started to produce guides for car journeys at the start of the twentieth century, giving birth to the *Michelin Guide*.

Michelin UK started selling tyres in 1905 from a base in London, and by 1911 it was also producing the first UK guides, which included road maps, recommendations for places to eat and stay, and of course, places where tyres could be purchased. It was from this guide that the Michelin Stars awards for fine dining originated. In the 1920s cars started becoming more commonplace and an ever-increasing demand for tyres followed. With more cars on the road, and many more people travelling to holiday destinations by car, sales of the Michelin Guides were boosted and maps with road numbering were introduced for the first time in the UK. With rising import taxes, a decision was made to start manufacturing tyres in the UK for the domestic market and Stoke-on-Trent was chosen, with the first tyres rolling off the production line in 1927.

The Dundee factory on Baldovie Road opened in 1972, manufacturing Radial Tyres, a design that incorporated steel cord to improve the stability of the tyre created by Michelin in 1946.

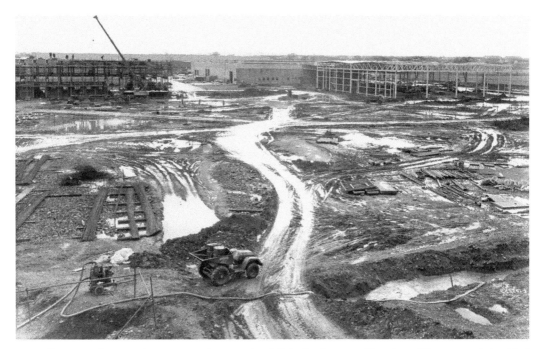

Construction work commencing at the Michelin factory, Dundee. (Photo used by kind permission of Michelin UK, Dundee).

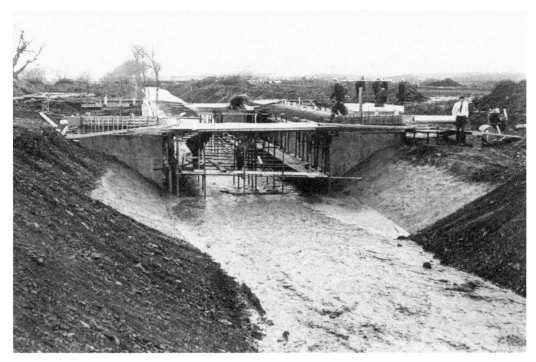

Construction work to create a new footbridge to the new Michelin factory, Dundee. (Photo used by kind permission of Michelin UK, Dundee)

Above: Ongoing construction work for the new Michelin factory, Dundee. (Photo used by kind permission of Michelin UK, Dundee)

Opposite Above: The complete factory in 1972. (Photo used by kind permission of Michelin UK, Dundee)

Opposite below: The first tyre produced at Michelin, Dundee. (Photo used by kind permission of Michelin UK, Dundee)

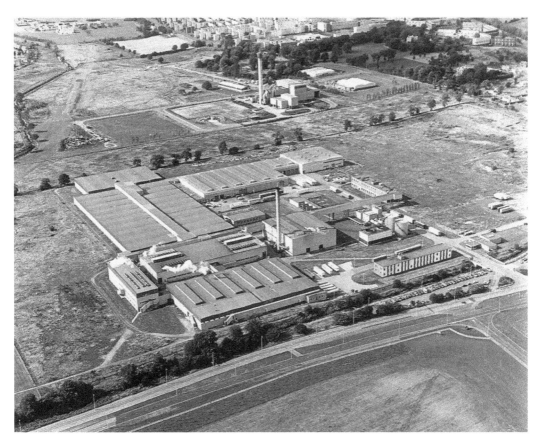

The facility had grown steadily over the years, with the 5,000,000th tyre being produced on 27 November 1975, and successfully weathered the difficult trading times of the early 1980s, when car manufacturing dropped considerably, by supplying the export market. By the mid-1980s, Michelin Dundee was manufacturing tyres that were considered to be the most advanced in Britain and in 2006 two well-known local landmarks were added to the site when the Dundee facility became the first Michelin plant to start utilising wind power. The 85-metre-high turbines with a 71-metre-rotor diameter have been helping to reduce costs at the factory since, and in 2014 it was announced that they had produced over 50 million units (kWh) since their installation. In 2013 alone, electricity generated was sufficient to have powered 1,500 homes.

While Michelin in Dundee has faced some difficult times, by adapting to the changing times combined with the commitment of the workforce, it has remained one of the largest employers in the city for the duration of its forty-five-year existence, with the current workforce being just under 1,000 people. It is estimated to bring around £45 million to the local economy annually, and the apprentice scheme creates many opportunities for local young people. The factory produces over 7,000,000 car tyres every year and with new investment announced, this is likely to increase further.

Extension work at the Michelin factory, Dundee. (Photo used by kind permission of Michelin UK, Dundee)

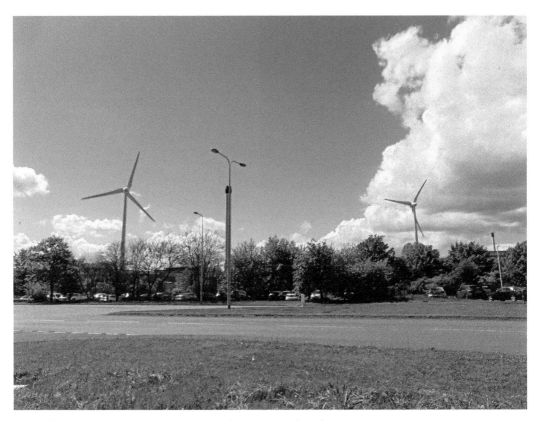

The wind turbines at Michelin, a well-known landmark.

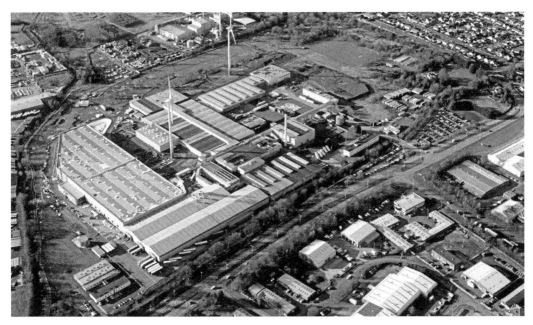

The Michelin factory from above. (Photo used by kind permission of Michelin UK, Dundee)

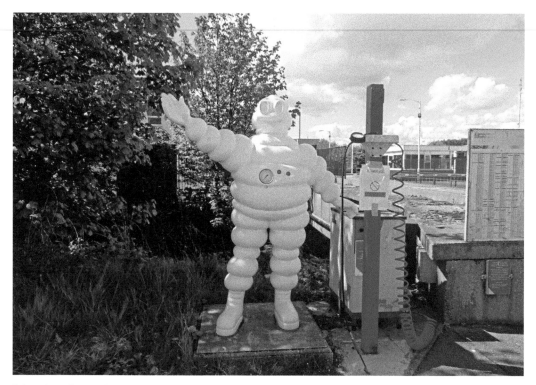

Bibendum, better known as The Michelin Man, welcoming workers to the factory. This world-famous trademark was created in 1998 from the imagination of the Michelin brothers when they noticed that a stack of tyres looked like the body of a man.

COMPUTER AND VIDEO GAMING

As mentioned previously, during the early 1980s the Sinclair ZX-81 was manufactured at the Timex factory in Dundee, with the ZX Spectrum following. These computers were largely responsible for bringing about a revolution in home computing, which quickly became a growth industry. Computer clubs were being opened all over the country to bring together budding computer engineers and programmers, and it was at the Kingsway Amateur Computer Club that the roots of the computer and video gaming industry in Dundee can be traced. It was here that four local men met: David Jones, a former employee of Timex; Russell Kay; Steve Hammond and Mike Dailly. Through a mix of visits to the amusement arcades in the city and their work and discussions at the computer club, they decided to work on creating computer games. David Jones had already used his redundancy money from Timex to purchase an Amiga 1000 computer and was working on developing a game named 'Menace'. He and Russell Kay had been working on a game called 'Moonshadow'. Mike Dailly began working on games for the Commodore 64, and Steve Hammond developed graphics for the games. In 1988, having seen some of their games already published, David Jones

founded the company DMA, which stands for Direct Memory Access and, with the other three on board, the rest, as they say, is history.

DMA initially operated from a small first-floor office at the bottom of the Perth Road and developed a number of games. But it was in 1991 when they developed the game 'Lemmings' that things really took off. The idea of the game was simple: a mass of Lemmings would drop onto a landscape filled with danger, and it was up to the player to create a clear pathway for the Lemmings to safely cross. The game earned rave reviews and on the day of release, an estimated 55,000 copies were sold. Versions of the game were created for different computer systems and the success saw sequels being released. In total, around 15 million copies of the game were sold. As the company grew, they moved to larger premises in Meadowside, before making the move to their base at the new Dundee Technology Park, which was being built on the outskirts of the city.

In 1993, DMA began to develop games for Nintendo; yet it was a game release for use on personal computers in 1997 named Grand Theft Auto that would go on to secure the company's position in the world of computer gaming. GTA, as

The former Dundee Technology College on the Kingsway where the computing club was held.

The first offices of DMA above the restaurant on the Perth Road.

The first offices of DMA was a tiny building sandwiched between much larger properties.

The building that houses the DMA offices on Meadowside.

Discovery House at the Dundee Technology Park.

The Lemmings Statue, commemorating the importance of the game in the growth of the industry in Dundee.

the game became known, was a worldwide hit and, although not selling as many copies as Lemmings had, it attracted the interest of larger organisations. DMA was bought by Gremlin Interactive in late 1997. Gremlin was later purchased by Infogamers, who in turn sold the former DMA division to Take Two Interactive, who already owned BMG Interactive, a company to which DMA already supplied games. The potential of GTA had been recognised, and DMA was tasked with developing further versions, with GTA: London 1961 and GTA 2 being released in 1999. It was around this time that DMA was renamed Rockstar Studios, and with the company moving to recently opened premises in Edinburgh, the Dundee operation was closed.

The impact of DMA on Dundee was undeniable. At the height of its success it was employing around 150 people, and inspired numerous other companies to set up in the city. David Jones, who had left DMA around the time it became Rockstar Studios, founded Realtime Works in 2002, and operated from a base in Dundee for eight years, bringing employment to over 200 people, before the company closed in 2010. He now runs Reagent Games, again based in Dundee. Perhaps a sign of the importance of computer and video games in Dundee, in 1997 Abertay University

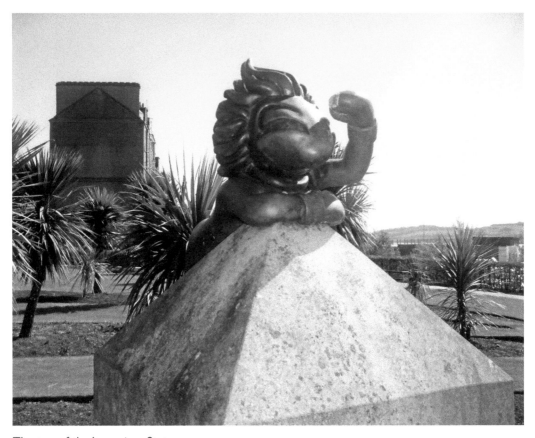

The top of the Lemmings Statue.

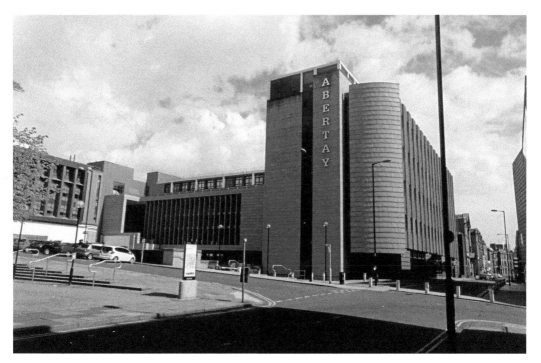

Abertay University.

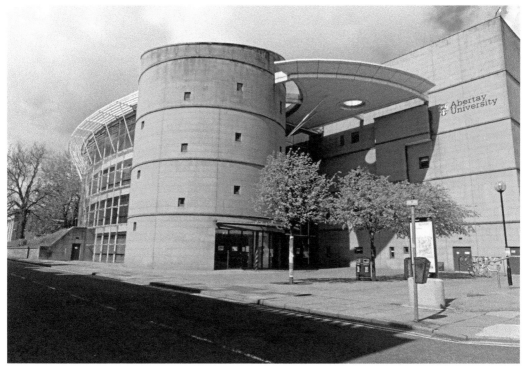

The state-of-the-art library of Abertay University.

Seabraes House in the Greenmarket. This building houses the offices for Tag Games, created in 2006 and now one of the largest developers of mobile games in the country.

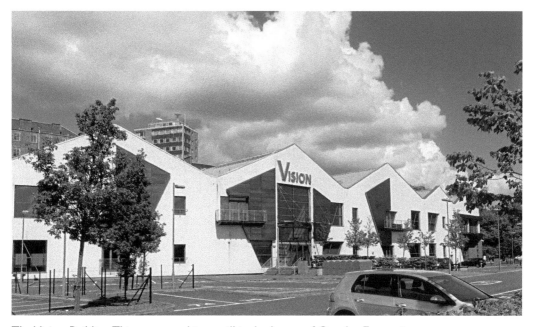

The Vision Building. This converted jute mill is the home of Outplay Entertainment.

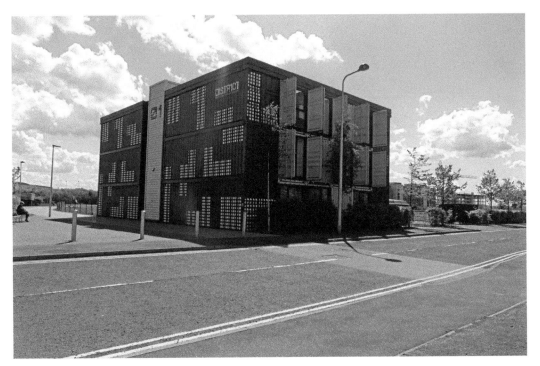

The District 10 Building at the Greenmarket. Built from thirty-seven shipping containers, this innovative building is specially designed to provide accommodation for early stage creative companies.

was the first university in the world to offer courses in games programming and design and became the first university in Europe to create a dedicated research centre for computer games and video entertainment. Games developers in the city have also moved to create games for the ever-changing technology, with Outplay Entertainment becoming the largest independent mobile developer in Scotland, employing 155 from their base in the Seagate.

In 1996, Dundee was selected to host the UK's biggest independent video games festival, and with around a third of games companies in the country being based in and around Dundee, the city remains well placed to continue to develop in this growth industry.

INSURANCE

Perth-based insurance company General Accident had operated in Dundee since the late 1800s. However, it was not until the start of the 1990s that the insurer became a major employer in Dundee.

Many companies, including General Accident, had started to find the London market difficult. Money from the growth of the oil fields started to flow into the capital during

the 1980s, which, along with deregulation of the financial sector, brought rapid growth as companies sought to have a presence in the city. With that, the 'Yuppie' (young upwardly mobile professional) culture arrived, with staff showing little loyalty to a company and moving around to where the ever-increasing opportunities were, with no thought for the investment their previous employers had made in their training. Having struggled to retain experienced staff, General Accident decided to buck the trend of moving operations to London and instead utilise modern technology to minimise their staff numbers in capital. More advanced computers allowed records to be increasingly computerised, allowing them to be accessed from around the country. It had become possible for someone to phone a local number and for the call to be diverted elsewhere in the country without the customer's knowledge and with no additional cost to them, and fax machines allowed documents to be transferred almost instantly. Dundee was selected for what was to become General Accident's London Service Centre, and a local workforce began to be recruited in the early 1990s, one of which on was myself. Staff underwent a week-long induction training at the General Accident office on Perth Road, before starting in the Service Centre's temporary base in the former NCR buildings at Kingsway Camperdown. During this time, a purpose-built facility was being constructed at the Technology Park.

It was, from my own experience, a good place to work. This was probably due to it being a completely new operation, with the majority of staff being new to the industry and there being just a few experienced staff brought in from all over the country to take up supervisory and managerial posts. The processes and technology were new to everyone, and there was a great culture of willingness to help one another through the learning process. Between 1992 and 1993, the staff moved to the new premises at the Technology Park, which was a large quadrangle providing over 5,000 square meters of office accommodation over two storeys, and parking for around 300 vehicles. Initially the Service Centre housed departments covering the four main areas of London in which the company was formerly based, split into personal insurance and commercial insurance, each with a claims department, underwriting department and accounts. Essentially, they continued to operate as separate branches, all housed within the one building. While this still created opportunities for staff, it was mainly through internal moves, which allowed the company to invest in training as they continued to retain the staff as they worked through their career. A competition was held among the staff to formally name the building, and Swan House was selected, named after a large swan sculpture in the central courtyard of the building.

This was still all a relatively new concept, yet it proved to operate successfully, and other branches were established within the building, including a Creditor Claims department serving banks and building societies, and a branch providing exclusive cover to customers of Liverpool Victoria following their purchase of Frizzell, an insurance broker specialising in home and motor insurance, in 1996. General Accident did not only utilise technology to create one of the first major call centres; they pioneered

new ways to deal with household claims, including providing replacement items direct to customers – a process now adopted by almost every major insurer today.

The year 1998 would, however, bring changes when General Accident merged with Commercial Union to form CGU Insurance. With two major insurers joining together, there was inevitable duplication both in the services provided and the locations of the offices. Swan House survived, mainly due to the large experienced workforce, but combining operations resulted in the former branch identities being no longer required and different services moving in. CGU would also suffer from the very principles that established Swan House. Just as technology had allowed services to be moved from London and offered to the customers from elsewhere, as technology continued to advance, it became possible for the same services could be offered to the whole of the UK from almost anywhere in the world, and call centres abroad started to open, providing services at reduced costs. In 2000 CGU merged with Norwich Union insurance, forming CGNU (which later rebranded as Aviva), which again created the situation of duplicate services and offices. Swan house again survived, but with a much-reduced workforce. One of the key issues was the close proximity of Pitheavlis, the former General Accident headquarters in Perth, to Swan House. Pitheavlis itself had been turned into a service centre, meaning that there were two large centres not far apart. Many of the services from Swan House started to move to Pitheavlis or other contact centres and, in 2008, Swan House was closed. The building lay empty until 2014, when Aviva announced that the facilities would be opened again to house charities and local community groups, which were given the use of the building free of charge. Although still occupied by the charities, the building was put up for sale in 2015.

The General Accident brand was reintroduced by Aviva in 2013; however, the connection with Dundee has sadly not returned.

TRAVEL AND TOURISM

Although Dundee has been a popular destination for a long time, it is in more recent years that the Travel and Tourism industry has really taken off.

The McManus Galleries have provided purpose built museum facilities in the centre of the city for over 150 years. Originally named the Albert Institute, after Prince Albert, the building was designed to include an art gallery, museum and a library and opened to the public in 1867, with extensions being added in 1873 and 1887 to house additional art galleries. The building was plagued with structural issues due to it being built on former marshland, until the mid-1980s. Significant cracking had been found in the building in the late 1970s and the Lord Province of Dundee at the time, Maurice McManus, fought for stabilising work to be undertaken, saving the building from further deterioration. The galleries were renamed after the Lord Provost in recognition of this work. In 2006, further major renovation work commenced, which included underpinning the building to provide stability and stone repairs, as well as

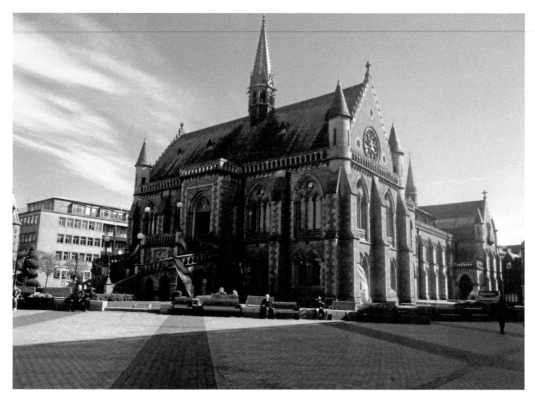

The McManus Galleries.

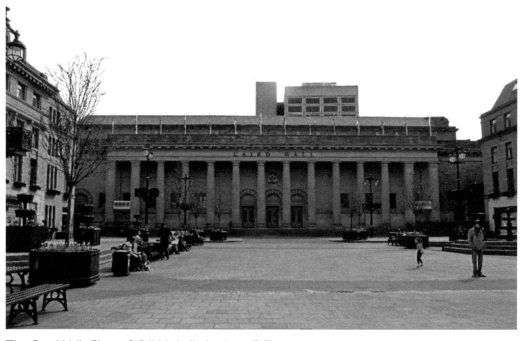

The Caird Hall. (Photo © Bill Nicholls (cc-by-sa/2.0)

either creating new or improving existing customer facilities. Today, the McManus Galleries remain the largest monument in memory of Prince Albert outside of London (albeit no longer carrying his name), and houses history from the city and the surrounding area covering an amazing 400 million years.

The Caird Hall is the main concert and events venue in the city, with the building itself dating back to 1914.

Sir James Caird, a local jute mill owner, donated £100,000 for the construction of the new hall, whose foundation was laid by King George V and Queen Mary on the site, previously home to slum accommodation known as The Vault. Construction work stopped temporarily due to the start of the First World War, and the building was finally completed in 1923. Over the years, it has welcomed many big-name stars including Frank Sinatra, The Beetles, Cliff Richard, Led Zepplin, David Bowie and Elton John, and it still offers regular concerts and shows to this day.

Another mainstay of the tourism industry is Camperdown Park and Wildlife Centre, which is situated on the outskirts of the city. The park is the former estate of Camperdown House, a nineteenth-century Greek-Revival mansion house built for Lord Duncan on the site of an earlier seventeenth-century mansion. Lord Duncan renamed the estate Camperdown after his father's victory as commander of the Royal Navy when they defeated the Dutch at the Battle of Camperdown in 1797, and in 1831 he was made Earl of Camperdown. In 1933, when the 4th Earl died with no direct descendants to inherit the title and estate, the title was lost and the estate passed to his cousin Georgina, the window of the 7th Earl of Buckinghamshire, before being bought by the Corporation of Dundee in 1949 and being officially opened as a public park.

One of the main attractions at the park is the wildlife centre, which has operated since the 1970s, and the firm favourite was Jeremy, the bear. Jeremy, a European Brown Bear, was in fact a female and also a TV star, having been used in adverts for Sugar Puffs. When she was replaced by a cartoon bear, she moved to Camperdown to live out her retirement until she sadly passed in 1991, aged twenty-five years. The park has two bears at the moment: Comet, aged thirty, and Star, aged twenty-eight.

Dundee was rebranded as 'The City of Discovery' when the ship sailed by Captain Scott on his 1901 expedition to Antarctica (mentioned earlier in the book) was docked at Discovery Point, a purpose-built five-star visitor attraction in 1993. In 2000, Sensations Science Centre (now Dundee Science Centre) opened a short distance away from Discovery Point, offering a 'hands-on' science experience, building on both Dundee's growing importance as a biomedical centre and offering a new 'discovery' element to the city.

Other aspects of Dundee's past have been brought back to life as part of the tourist industry, including the frigate *Unicorn* which, although not built in Dundee, served as a training ship in the Tay for the Navy since 1873 and acted as the headquarters for senior naval officers in Dundee during both world wars. During the late 1960s, the ship was withdrawn from service and the process commenced

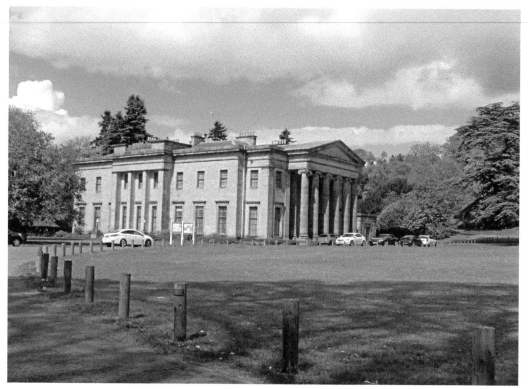

Camperdown House.

Camperdown Wildlife Centre entrance.

A carving of a bear near the entrance to Camperdown Wildlife Centre.

to establish the *Unicorn* as a living museum to the naval past, offering an insight into Dundee's past shipping industry.

The Verdant Works, mentioned earlier in the book, having been bought by the Dundee Heritage Trust in 1991, underwent repair work and opened in 1996 as a museum to the city's jute industry. The High Mill at the premises was later restored and opened to the public in 2015. With working machinery and audio to tell the stories of the mill's working life both inside and out, the Verdant Works offers excellent tourist facilities.

New hotels are also being created in the city – some fully restored former hotels and some complete new builds.

It is estimated that in 2015 more than £100 million was spent in Dundee by visitors to the city, and this is set to rise thanks to the thirty-year riverfront development, which commenced at the start of the twenty-first century. This development includes new hotel facilities, and the Victoria and Albert Museum of Design Dundee, which is dedicated to telling the story of Scotland's design heritage and is expected to create around 7,000 jobs, giving a clear indication that this is an industry expected to grow in Dundee.

One of the penguins at Discovery Point. (Photo courtesy of Kyle R. Stewart Photography)

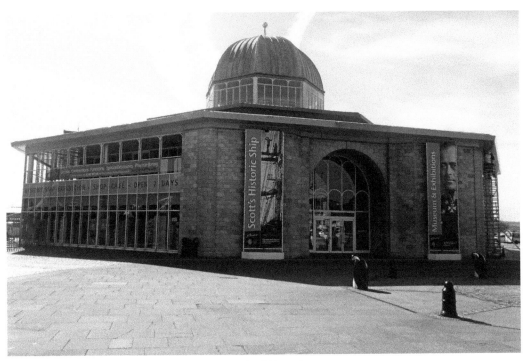

Discovery Point visitors' centre at Dundee Waterfront.

The now famous penguin statues in the city centre that commemorate the role of the shipping industry in voyages to the Arctic and Antarctica. These are a popular photo stop for visitors.

Dundee Science Centre.

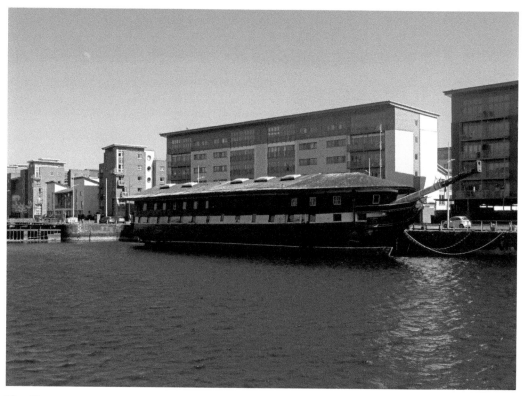

The *Unicorn*, moored in the Victoria Dock.

The City Quay, offering a mix of shopping and restaurants on the dockside.

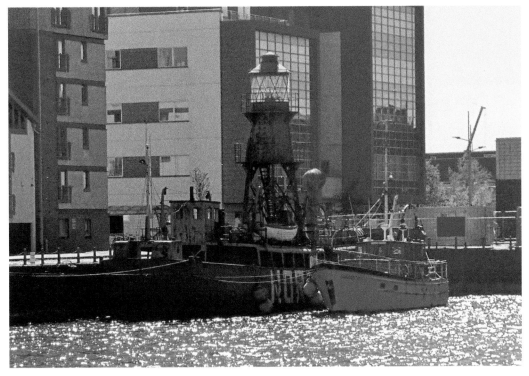

The *North Carr* lightship. Currently in very poor condition, the *North Carr* is the last remaining lightship and it is hopeful funds can be raised to restore it and open it as an attraction.

The Verdant Works.

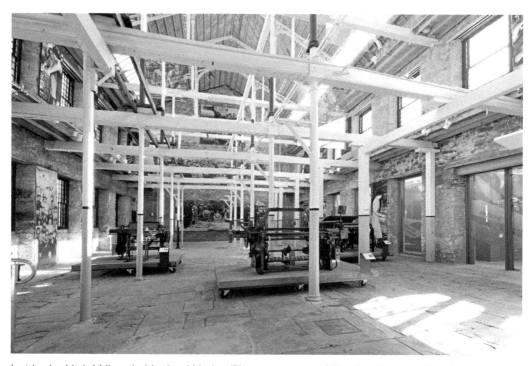

Inside the High Mill at the Verdant Works. (Photo courtesy of Dundee Heritage Trust)

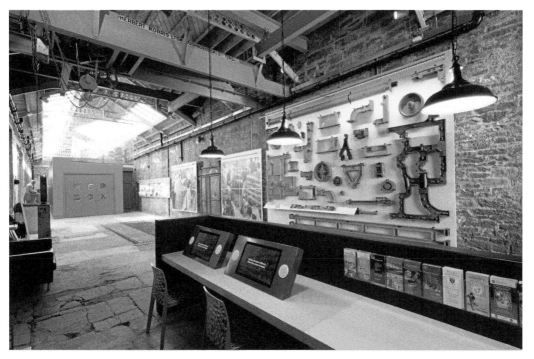

Inside the High Mill at the Verdant Works. (Photo courtesy of Dundee Heritage Trust)

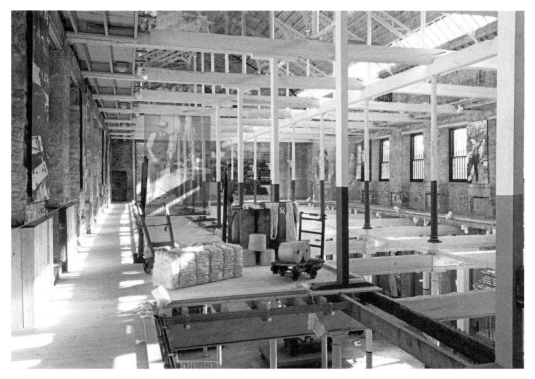

Inside the High Mill at the Verdant Works. (Photo courtesy of Dundee Heritage Trust)

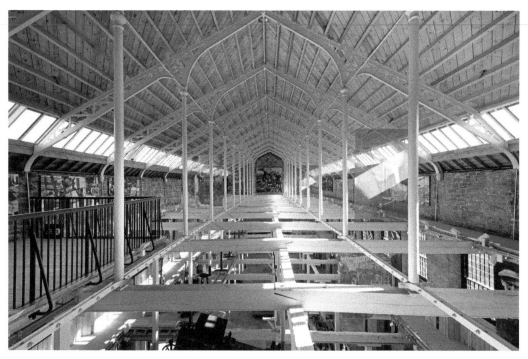

Inside the High Mill at the Verdant Works. (Photos courtesy of Dundee Heritage Trust)

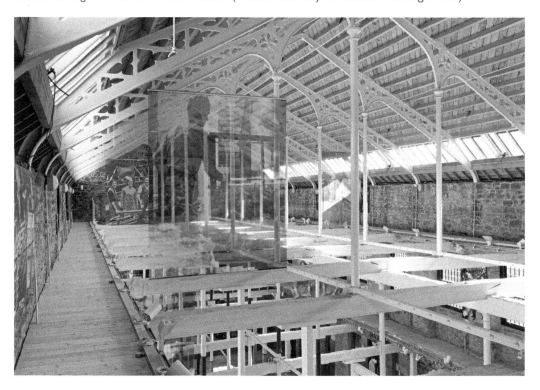

A new hotel being built, forming a new entrance to the railway station.

Above: The former Tay Hotel, a once grand building that had fallen into a state of disrepair and which has now been fully restored.

Opposite above: A budget hotel occupying part of a former Jute Mill.

Opposite below: The V&A Museum from the roadside.

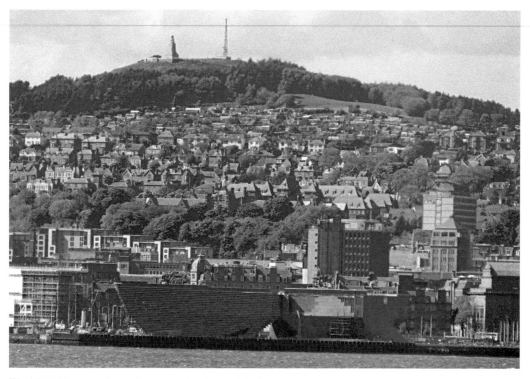

The V&A Museum from the opposite side of the Tay.

The V&A from the Dundee Law.